IMAGES
of America

THE PONY EXPRESS
IN UTAH

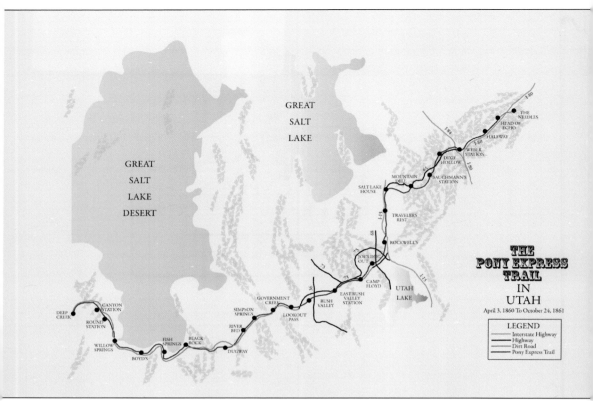

This map depicts the overland mail route of the Pony Express through the present-day state of Utah. From April 1860 until October 1861, riders traveled from St. Joseph, Missouri, to Sacramento, California, carrying light letter mail, linking the East to the West. The people and resources in Utah played a pivotal role in the success of this horseback mail service. (Courtesy Carol Hatch.)

ON THE COVER: A Pony Express rider leaves Simpson's Springs Station, one stop of many in Utah along the 2,000-mile Pony Express route from St. Joseph, Missouri, to Sacramento, California. The Pony Express was formed in 1860 by three Missouri businessmen in an effort to speed mail delivery to the fledgling state of California. At the time, it could take several months for a letter to travel from the East Coast to the West by stagecoach or boat. The Pony Express cut the amount of time it took to cross the western half of the continent to 10 days. (Photograph by Brian McClatchy; courtesy Patrick Hearty collection.)

IMAGES
of America

THE PONY EXPRESS
IN UTAH

Patrick Hearty and Dr. Joseph Hatch

ARCADIA
PUBLISHING

Published by Arcadia Publishing
Charleston, South Carolina

Printed in the United States of America

Library of Congress Control Number: 2014952490

For all general information, please contact Arcadia Publishing:
Telephone 843-853-2070
Fax 843-853-0044
E-mail sales@arcadiapublishing.com
For customer service and orders:
Toll-Free 1-888-313-2665

Visit us on the Internet at www.arcadiapublishing.com

*This book is dedicated with love and gratitude to
our patient wives, Linda and Annette.*

CONTENTS

ACKNOWLEDGMENTS

A project such as this is not brought to completion without help and encouragement from a lot of people. We are particularly indebted to Richard Hale of Hale Video Services. His expertise in manipulating old photographs is incredible; his response to our requests was almost instantaneous. Brittany Chapman at the Church History Library of the Church of Jesus Christ of Latter-day Saints was invaluable in helping us retrieve archival photographs from that source. We deeply appreciate Dr. Richard Turley, assistant LDS Church historian, for his enthusiasm and encouragement as our research proceeded. The ladies at the Daughters of Utah Pioneers Museum were of great help in finding photographs of Pony Express riders. Robert Manasek at Scotts Bluff National Monument provided easy access to its William Henry Jackson collection. Carol Hatch offered the beautiful trail map. Others who provided assistance and advice, or offered old photographs from their personal collections, include Beth Bagley Anderson, Charles Bagley, Dr. David Fairbanks, Dr. Craig Fuller, Becky Kimber, Marilyn and Pie Linares, Arleta Martin, Roseann McPhaul, retired Park Service interpretive specialist Chuck Milliken, Curtis Brent Moore, Stewart Paulick, and John Rockwell. Our wives, Linda and Annette, suffered in silence as we did field and computer research, sorted through stacks of old photographs, and met to hammer out details. Annette also provided photographs. And, not least of all, we are most grateful to our Arcadia Publishing editor, Alyssa Jones, for her guidance and patient encouragement.

INTRODUCTION

Civilized man has always had a desire for rapid communication. Before the industrial age, the horse was often the transportation medium of choice. This was particularly true for military operations. Mongol emperor Genghis Khan developed a postal system based on horseback relays in the 13th century. At the peak of its operation, the Khan's "pony express" could carry a message approximately 4,225 miles across Mongolia in about two weeks, covering an average of 300 miles per day. Good communications helped him conquer an empire of nearly 12 million square miles.

In Europe, as cities were built and commerce increased, messengers on horseback or in horse-drawn conveyances carried mail and messages throughout the lands not served by seaports. The Dutch Post Road, connecting the Netherlands with areas of Germany and Italy, was established in 1490. Regular mail service in northern Germany was offered on the Bremen-Hamburg Post Road in 1665. In North America, the Boston Post Road was a system of roads laid out in the 1600s to provide mail transportation between Boston and New York City. These paths were soon improved and widened to allow passage of wagons and coaches, and they eventually evolved into the country's first highways.

As America experienced its westward expansion, the distances and emptiness of the new land presented challenges to those who wished to maintain communication. After Lewis and Clark and the Corps of Discovery left the Mandan villages on the Missouri River in April 1805, they had no further communication with Pres. Thomas Jefferson until their return to St. Louis in September 1806. Upon their return, Meriwether Lewis wrote a letter describing their success, which took almost a month to reach Jefferson. The intrepid fur trappers who went west following the beaver from the late 1600s until about 1834 must have been accustomed to spending an entire winter season almost totally isolated from other white men. The rendezvous season offered their only opportunity to receive letters and news from home.

The first emigrant wagon train to enter present-day Utah was led by John Bidwell. It traveled down from Soda Springs in the summer of 1841 and crossed north of the Great Salt Lake to Pilot Peak on its way to California. In 1847, Brigham Young brought the exiles from the Church of Jesus Christ of Latter-day Saints into the Salt Lake Valley. Great Salt Lake City became the only substantial settlement in the Great Basin, as thousands of church members from the East and converts from Europe followed the Mormon Trail in search of religious freedom and new opportunity in the territory they called Deseret. Emigrant travel to California was still a relative trickle until January 1848, when James Marshall plucked a nugget of gold from the tailrace of John Sutter's mill at Coloma, California. Word got back to the states later that year, and, in the spring of 1849, the Gold Rush was on. The "forty-niners" came in droves by land and by sea to try to claim their piece of El Dorado. San Francisco, or Yerba Buena as it was called until 1847, was a sleepy village of 200 in 1846. By 1852, it had become a booming town of 36,000. By some estimates, approximately 300,000 people had flocked to California by the year 1855, considered the end of the Gold Rush era.

So, by 1860, the overland emigration had been under way for nearly 20 years, and the population west of the Rocky Mountains exceeded a quarter of a million people. Few of those transplanted

Easterners, especially the newly minted Californians, were without family or business ties back home. Additionally, there was great curiosity, if not anxiety, concerning the unrest between North and South as events led toward the Civil War. Communication was becoming an increasingly important issue.

In the early days of the westward movement, letters were often sent with a traveler, trusting in his promise to deliver or mail it in "the States." Messages for a following wagon train were sometimes left stuck on a post alongside the road. Brigham Young is said to have left messages written on a buffalo skull. Mail was later brought to California via the Isthmus of Panama, but delivery time was generally four to six weeks. The Central Overland Route, through the center of the country and following the much-used emigrant trails, seemed a logical solution to many in the West. Young organized several attempts to expedite mail delivery from the East, with little success. Early efforts to carry mail along the central route were generally underfunded, often inadequately equipped, and subject to winter-related delays of as much as six months. Maj. George Chorpenning is best known among those who tried to overcome such obstacles. Chorpenning and partner Absalom Woodward received a mail contract in 1851 calling for monthly delivery between Salt Lake City and Sacramento. Chorpenning suffered great personal hardship and financial loss, and Woodward lost his life to hostile Indians in Utah's west desert. Many in Congress and the East believed that problems of weather, terrain, and Indians made year-round travel on the central route unfeasible.

By 1858, the primary overland mail route to California was the stage route of John Butterfield. The Butterfield stage left St. Louis, swung south to Fort Smith, Arkansas, and El Paso, Texas, then west to California. Commonly known as the "Oxbow" Route, because of its shape on a map, Butterfield's trail was nearly 1,000 miles longer than the more direct central route. It was also decidedly unsatisfactory to the Mormons in Utah. Butterfield's route was also vulnerable to Indian depredations, and it led through Southern territories with strong secessionist sentiments.

It is not known for certain who originally proposed the idea of an overland Pony Express. But the concept apparently came to life after some discussion between William H. Russell, of the freighting firm Russell, Majors & Waddell, and William M. Gwin, influential senator from California. Russell's partners, Alexander Majors and William B. Waddell, were highly skeptical of the investment required and of the considerable risk. But the ebullient Russell had made commitments, and he convinced them that if the endeavor proved successful, mail contracts would be forthcoming to make it profitable.

Once the decision was made, progress was remarkably rapid as the Pony Express came into being. Under the umbrella of Russell, Majors & Waddell, the Central Overland California & Pikes Peak Express Company was formed. All along the line between St. Joseph, Missouri, and Sacramento, California, the early spring of 1860 was a busy one. Initially, 80 riders were hired—young, hardy frontiersmen, and the best horsemen that could be found. About 500 horses were purchased, largely well-bred cavalry horses from the East and tough California mustangs from the West. Horses were chosen with great care, as the riders would be counting on superior horseflesh to outrun Indians and road agents. Saddles were light, stripped-down models, and the mail was carried in a *mochila*, a leather saddle cover with holes cut for horn and cantle. Leather pockets, or *cantinas*, were sewn at each corner.

Relay stations for changing horses were established at approximately 25-mile intervals. Additional stations were added when the distance was found to be too great for a single horse over rough terrain. Home stations were designated at intervals of about 75 miles. A rider would carry the mail from one home station to the next, changing horses at each swing or relay station, then hand the mochila to the next rider on the line.

And so, from early April 1860 until late October 1861, the fastest means of communication between the western parts of the North American continent and "the States" was the horse-and-rider relay system known as the Pony Express. It was put into service without government subsidy or the support of the US Postal Service. The enterprise, though short-lived and financially disastrous, has been described as "an extravagant, flamboyant expression of frontier bravado and accomplishment,"

and its actual impact on the opening of the West has been debated. Still, "the Pony" stands after more than 150 years as one of the most recognizable and beloved icons of American history. It has been suggested that perhaps people are drawn so strongly to the Pony Express because it was the last important communication medium dependent on blood, muscle, and sinew for its execution, the last to which people could personally relate. From that day to this, there has been an ever-accelerating cascade of technological innovation. Or, perhaps, people love the Pony because of the innate romance found in the idea of youth and horseflesh conquering the obstacles of time and distance. For these reasons, or for others, few episodes in the United States' Western history have captured the imagination of Americans and the world as has the Pony Express.

On October 24, 1861, the transcontinental telegraph line was completed, the final connection being made in Salt Lake City. Using Samuel Morse's code, messages could now be sent across the country in minutes rather than days, and, as someone has said, the thunder of the Pony Express bowed to the lightning of the telegraph. Then, a few years later, on May 10, 1869, the Transcontinental Railroad linked East and West with steel rails instead of telegraph wire. Not only messages and information, but passengers and materials of every sort traveled on those rails, accelerating the settlement of the West and bringing to an end the pioneer era in Utah. The last pole on the first transcontinental telephone line was set on June 27, 1914, and voice communication across the country became possible. With advances in aviation, letter mail and parcels were delivered by air fairly early in the 20th century. As technology continues to advance, so does the rapidity and sophistication of communication. Computers and communication satellites ushered in a new era in message transmittal. Cellular phones and instant messaging now exist, and who can guess what developments will come in the future?

The events of this horseback mail service took place just prior to and during the beginning of the Civil War. Historians of the time were rightly focused on the war, perhaps the pivotal episode in American history. Nearly 50 years later, some began to look back, realizing that something significant had been overlooked. By the time they began to try to reconstruct Pony Express history, the records were lost, many of the participants were gone, and only a mixture of often hazy history and legend remained. Company records, accurate lists of riders and station keepers, more accounts of their adventures—these are things to be wished for. But, something about the image of an intrepid young rider on his fleet mustang, racing across prairie, mountain, and desert, defying all obstacles in his way, continues to stir the romantic spirit.

The first known Pony Express Re-ride was conducted between St. Joseph, Missouri, and San Francisco, California, in August and September 1923. According to newspaper accounts, it appears to have been something of a race and seems not to have followed the Pony Express Trail known today. In 1935, to celebrate the diamond jubilee, a re-ride took place involving about 300 members of the Boy Scouts of America. The Pony Express Centennial in 1960 featured a ride in both directions, as well as placement of numerous bronze markers along the trail. Governors of all eight Pony Express Trail states were members of the National Pony Express Centennial Association, with Pres. Dwight D. Eisenhower as honorary chairman. Since 1980, the National Pony Express Association (NPEA), which has its roots in the Centennial Association, has conducted an annual re-ride of the trail between St. Joseph, Missouri, and Sacramento, California. NPEA put on a two-way ride in 1985 to commemorate the 125th anniversary, and, in 2010, the association celebrated the Pony Express Centennial. A kickoff event in Washington, DC, the building of a large and impressive monument in Sydney, Nebraska, and celebrations in dozens of cities and towns along the trail during the re-ride were among the highlights. Utahns came out in droves in towns like Callao, Fairfield, Eagle Mountain, and Henefer to pay their respects to that colorful episode in the state's history. Hundreds attended a ceremony at This Is the Place Heritage Park in Salt Lake City.

The intent of this book is to keep the spirit of the Pony Express alive and well into the 21st century. We hope the reader will find it both interesting and informative. We feel that some understanding and appreciation of history and heritage is vital to our sense of place in today's world. Thanks for your interest.

One

PIONEER MAIL SERVICE BEFORE THE PONY EXPRESS

Pioneer communication in the American West before the days of the Pony Express moved by a variety of modes of transportation, most of them slow. The majority of the forty-niners who flocked to California in search of gold went West with the hope of getting rich, then returning to homes and families in the States. They were hungry for wealth, but equally hungry for news from back home and letters from loved ones. Weeks-old, even months-old letters and newspapers were welcomed, but left the recipient wishing for something more efficient.

The Mormons sought solitude in the Great Basin, but still felt a yearning for communication with the rest of the country. Valiant efforts to keep open links from Salt Lake City included George Chorpenning's Jackass Mail between Salt Lake and California, and several attempts at mail service from the East, including Brigham Young's BY Express Company. Lack of funding and political pressures led to their eventual failure. The Pony Express of Russell, Majors & Waddell was a long-awaited and much-heralded leap forward in pioneer communication.

The Pony carried only light-letter mail and telegrams. Before, during, and after the era of the Pony Express, parcels and newspapers, as well as goods, were transported throughout the West by pack train, stagecoach, and wagon. The stagecoaches of John Butterfield and, later, Benjamin F. Holladay, crisscrossed the West and Southwest, providing transportation for passengers and mail, even money and bullion. More remote areas of the West depended on the horse for mail, even long after the end of the Pony's run and the establishment of the telegraph. A stagecoach line was operating from Salt Lake City into eastern Nevada as late as 1917. In southern Utah, into some of the smaller and more remote communities, mail was delivered by pack train until 1935.

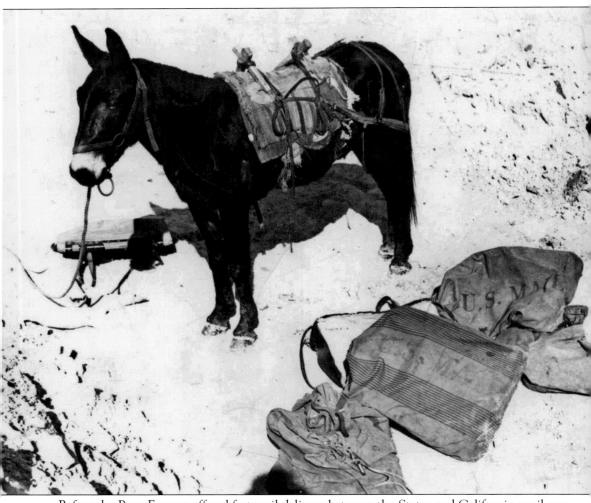

Before the Pony Express offered fast mail delivery between the States and California, mail was carried over the trail by pack mule. In 1851, George Chorpenning and his partner, Absalom Woodward, received a US Mail contract for service between Salt Lake City and Sacramento. The contract called for monthly mail delivery between the two cities. Woodward was killed by Indians on the Humboldt River in present-day Nevada, but Chorpenning persisted with his Jackass Mail service until 1860. Chorpenning established a series of relay stations, some of which were later used by the Pony Express. (Courtesy Utah State Historical Society.)

Mail, newspapers, and other supplies were delivered by packhorse to remote settlements throughout the West both before and after the days of the Pony Express. This rider drives a packhorse carrying the US Mail between Panguitch and Escalante in southern Utah in 1907. The isolated town of Boulder, Utah, received its mail by packhorse and mule until 1935. (Courtesy Utah State Historical Society.)

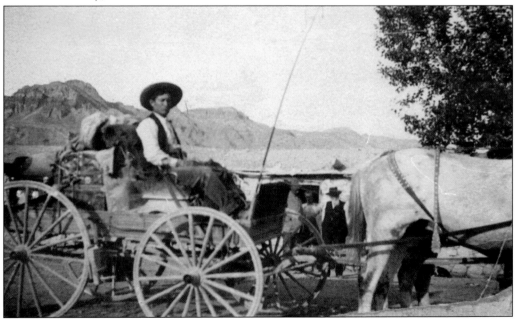

Buckboards, spring wagons, and various lighter horse-drawn conveyances were popular and important means of transportation in the days before the automobile, and would have been used to carry mail and parcels. George Kelly drives this buggy at Fish Springs while John Thomas looks on. (Courtesy Utah State Historical Society.)

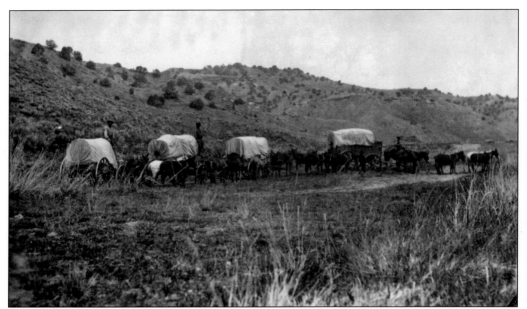

Before the coming of the railroad, supplies to Salt Lake City and the West were transported by wagon train. Mail sent by this means could take up to four months to arrive at its destination. No wonder people in the West were so enthusiastic when the Pony Express offered mail delivery between St. Joseph and Sacramento in only 10 days. This c. 1850 photograph shows a train of Kimball & White freight wagons in Echo Canyon. (Courtesy LDS Church History Library.)

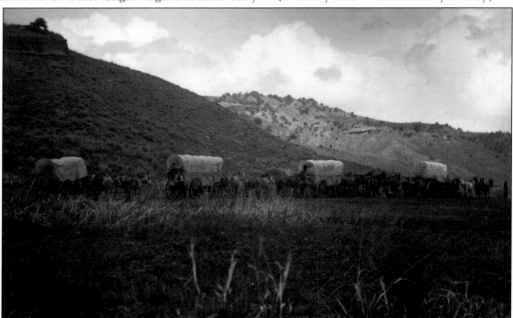

Westbound emigrants in the mid-1800s usually traveled by covered wagon train. Horses, mules, oxen, and even cattle were used to pull wagons carrying everything a family could bring. These settlers hoped to start a new life in the West. Letter mail and probably parcels also were sometimes sent with a westbound wagon train. (Courtesy Utah State Historical Society.)

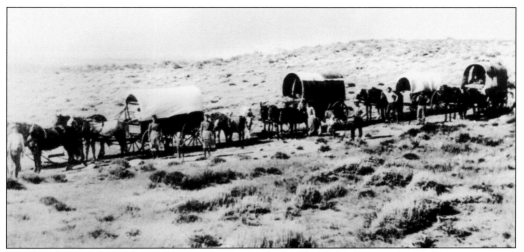

A Salt Lake City–bound wagon train is seen near the head of Echo Canyon. The Mormon pioneers came by wagon, handcart, and just about any available means to make their way to their Zion. (Courtesy LDS Church History Library.)

This C.W. Carter photograph of an 1867 wagon train coming down Echo Canyon suggests the hardship and difficulties encountered by pioneer families traveling west. Creeks at flood stage, as Echo Creek was here, along with waterless deserts, dust, mosquitoes, and monotony were among the challenges faced by those intrepid souls who left comfortable homes, friends, and family in search of religious freedom or economic opportunity and a new life in the West. (Courtesy LDS Church History Library.)

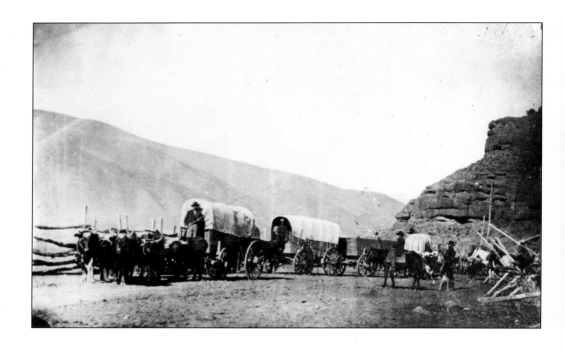

Although slower in their progress, oxen were more durable draft animals for pulling wagons, and were often the preferred choice for westbound emigrants. Mail and messages were undoubtedly sent with the emigrant trains: "Please give this letter and my love to Aunt Hattie when you get to Utah Territory." The ox-drawn wagons above were photographed in Echo Canyon in 1866. (Above, courtesy Utah State Historical Society; below, courtesy Bureau of Land Management.)

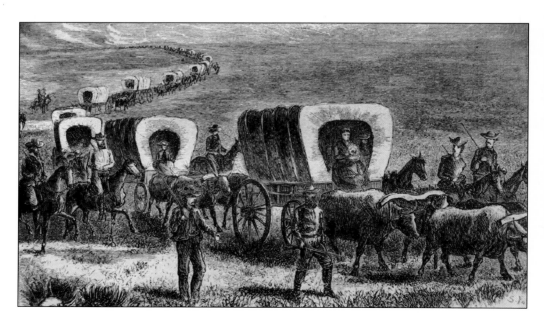

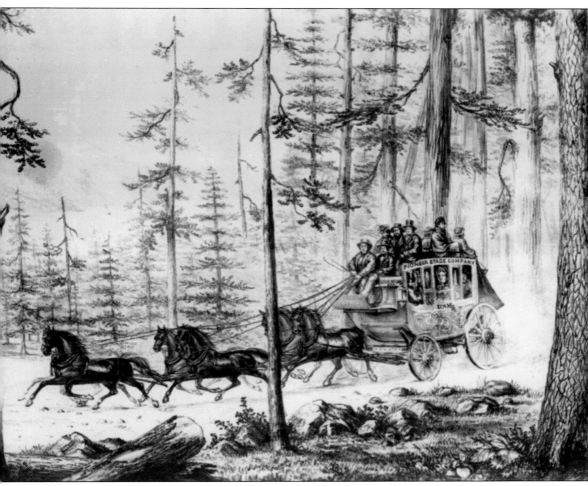

Shipler Commercial Photographers recorded a great deal of historical material early in the 20th century, including this drawing of a stagecoach. Its signboard reads "Pioneer Stage Company." Stagecoach travel began in the United States in 1756, with coaches running between Philadelphia and New York City. By the mid-1800s, a network of stage lines, such as that run by John Butterfield, crisscrossed the West, carrying passengers, freight, and mail. (Courtesy LDS Church History Library.)

The stagecoach body rested on a pair of thorough braces, long leather straps that supported the coach and provided suspension. The coaches traveled at an average speed of about five miles per hour, changing teams usually at 10- to 20-mile intervals, or stages. Stagecoaches were built in a variety of designs. The one pictured here appears to be without a solid top. (Courtesy Utah State Historical Society.)

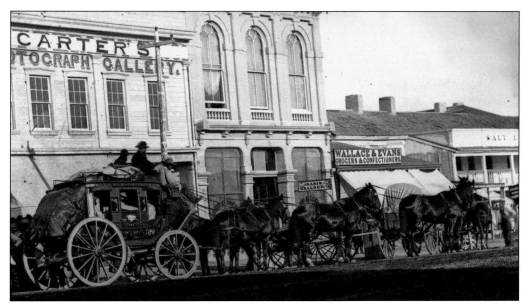

The stagecoach, like the one shown here in downtown Salt Lake City, was a popular mode of transportation in the West in the late 1800s. The coaches carried passengers, freight, and mail, traveling in stages between stations, where horses were changed and passengers found refreshment. Stagecoaches served many parts of the West long after the completion of the Transcontinental Railroad. (Courtesy LDS Church History Library.)

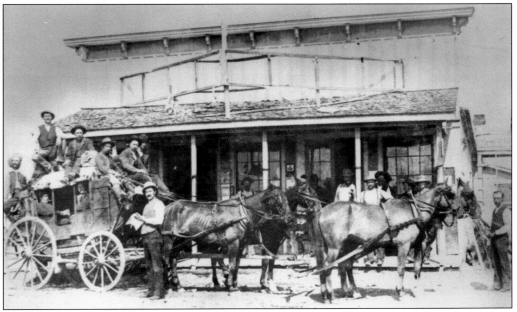

This four-horse stage was photographed by L.H. Lourd Commercial Photography Shop. When the coach was full, passengers commonly rode on top with the baggage and mail sacks. Indeed, at times, the top of the coach may have been a preferred location, situated higher and out of the dust. Sam Clemens (Mark Twain) describes a delightful ride atop a stagecoach on his 1861 journey to Carson City, Nevada. (Courtesy Utah State Historical Society.)

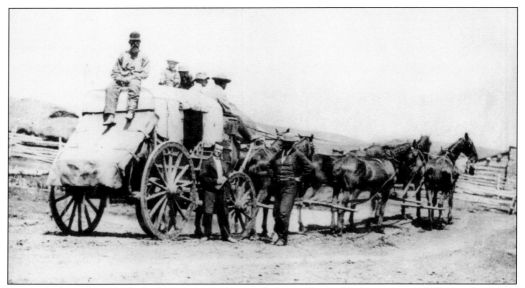

A coach from Ben Holladay's Stage line is seen here at Kimball's Junction in 1867. In the latter half of 1861, as the Central Overland California & Pikes Peak Express Company—which operated the Pony Express—sank into bankruptcy, it was taken over by stage-line magnate Holladay. (Courtesy Utah State Historical Society.)

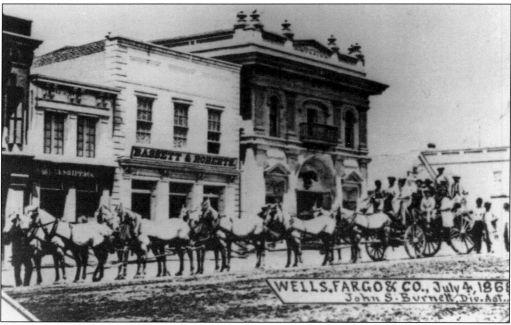

This 10-horse coach belonging to Wells Fargo & Company was photographed on East Temple Street (now Main Street) in Salt Lake City on July 4, 1868. It must have taken a driver of consummate skill to handle a team of 10 horses. The store in the background, Bassett & Roberts, was owned by Charles Henry Basset and Bolivar Roberts. In 1860, Roberts was division superintendent for the section of the Pony Express from Roberts Creek (now in Nevada) to the western terminus in Sacramento. (Courtesy Utah State Historical Society.)

Two

PONY EXPRESS RIDERS, COMPANY OFFICIALS

"Wanted. Young, skinny, wiry fellows, not over 18. Orphans preferred." As romantic as it sounds, and as popular as it has become, such an advertisement was never used to recruit riders for the Pony Express. It first appeared in a Western publication called *Sunset* magazine in 1923. Most of the riders were young men in their twenties; the oldest to carry the mail, so far as is known, was Maj. Howard Egan. He was 46 years old when he made the first eastbound mail run between Rush Valley Station and Salt Lake City on April 7, 1860.

The riders were chosen for their light weight and skill with horses. One of the founders, Alexander Majors, recalled, "Not only were they remarkable for lightness of weight and energy, but their service required continual vigilance, bravery, and agility . . . men of strong wills and wonderful powers of endurance." They rode between 75 and 100 miles, changing horses every 10 to 20 miles, averaging 10 miles per hour. According to rider Elijah Nicholas Wilson, they were required to "swear that we would at all times be at our post, and not at any time be over one hundred yards from the station, except when we were carrying the mail. When we started out we were never to turn back, no matter what happened, until the mail was delivered at the next home station. We had to be ready to start back at a half-minutes' notice, let it be day or night, rain or shine, Indians or no Indians." Wilson also said that, in spite of the lure of adventure and high wages ($25 per week at the outset), many riders could not stand up to the rigors of the job.

Located on the Central Overland Route, Utah and Salt Lake City were in a unique position to provide support and resources to the Pony Express. Division superintendents on the western half of the line were Utah men. James Bromley was in charge between Pacific Springs, in Wyoming, and Salt Lake City. Major Egan took over from Salt Lake to Roberts Creek, now in Nevada, and Bolivar Roberts had the reins from Roberts Creek to Sacramento. Ephraim Hanks, Porter Rockwell, and Peter Neece are among Utahns who served as station keepers. And the young men of Utah carried the mail. Of them, James Bromley said, "Nobly and well did they do their work."

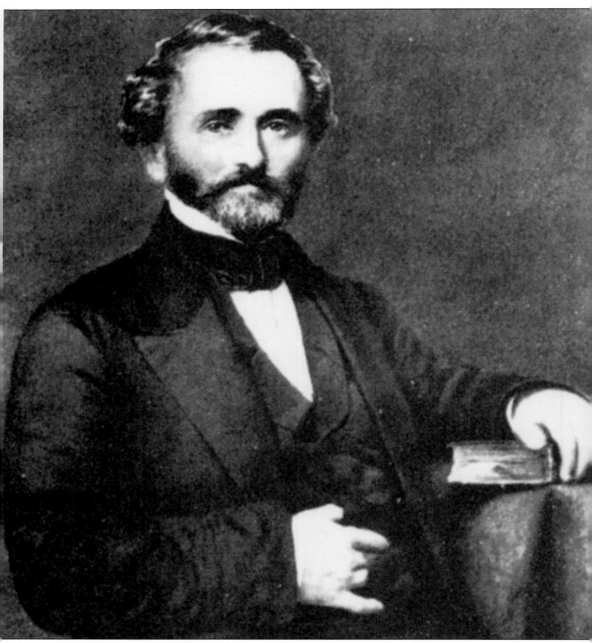

William Hepburn Russell was a partner with Alexander Majors and William B. Waddell in both the freighting firm Russell, Majors & Waddell, and the Central Overland California & Pikes Peak Express Company, which operated the Pony Express. Russell, a dreamer and entrepreneur, preferred the Eastern social scene to the rugged frontier life. He was confident that establishment of the Pony Express would lead to a lucrative mail contract. When the Pony proved unprofitable and the company fell into debt, Russell's machinations led to embarrassment, imprisonment, and financial ruin, with dissolution of both the freighting enterprise and the Pony Express company. (Courtesy Utah State Historical Society.)

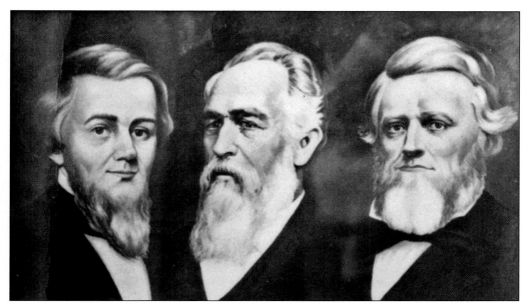

From left to right, William H. Russell, Alexander Majors, and William B. Waddell owned and operated a mammoth freighting business on the plains in the mid-1800s. The men were also the driving force behind the Central Overland California & Pikes Peak Express Company, which ran the Pony Express. Russell was the planner, the schemer, and the dealmaker. Majors was a hands-on freight-line operator. Waddell was the bookkeeper and cautious businessman. (Courtesy Daughters of Utah Pioneers.)

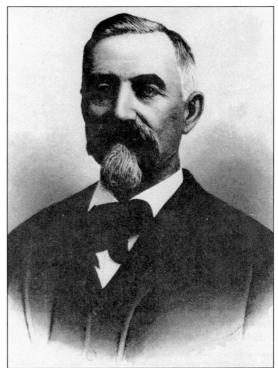

James E. Bromley settled at Echo, at the mouth of Echo Canyon, in 1854. He was hired by Russell, Majors & Waddell to superintend the Pony Express line between Pacific Springs (now in Wyoming) and Salt Lake City. He tells of buying horses to stock the line and of hiring Utah's young men to carry the mail. Bromley operated the Weber Stage and Pony Express Station, a home station for the Express riders. When the Pony Express came to an end, Bromley stayed on at the growing city of Echo, where he owned a store, a ranch, a hotel, and even an amusement park. He died on March 11, 1897. (Courtesy Utah State Historical Society.)

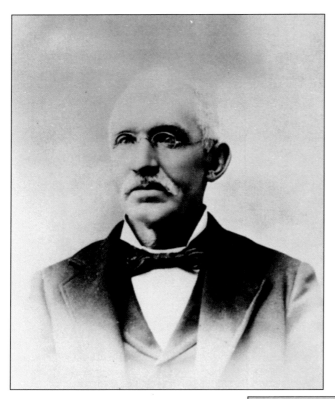

Henry Jacob Faust was born in Heddesheim, Germany, on June 18, 1834. His family immigrated to the United States and settled in Missouri. He joined the California Gold Rush in 1849, but, having little success, returned to Utah in 1851, where he built and operated a ranch and station in Rush Valley, south and west of Salt Lake City. Rush Valley, or Meadow Creek Station served as a home station for the Pony Express riders, the first home station west of Salt Lake City. Earlier in his life, Faust had studied medicine; although lacking a medical degree, he used his skills and knowledge to the benefit of both settlers and natives. "Doc" Faust, as he was known, was held in high esteem in frontier Utah. He died in Los Angeles on December 4, 1904. (Courtesy Daughters of Utah Pioneers.)

Howard Egan was born in Tullamore, Kings County, Ireland, in 1815, and immigrated to Canada with his parents at the age of eight. He and his wife, Tamsen, joined the Church of Jesus Christ of Latter-day Saints in 1842, and moved to Nauvoo, Illinois. Egan held the rank of major in the Mormon militia called the Nauvoo Legion, and was proud to carry that title throughout his life. He acted as a scout for Brigham Young's 1847 Vanguard Company of Mormon pioneers, and in subsequent years, explored much of the central route across present-day Nevada that was followed by the Pony Express. He was superintendent of the section of the route between Salt Lake City and Roberts' Creek, now in Nevada. Major Egan carried the first Pony Express mail eastbound from Rush Valley Station to Salt Lake City on April 8, 1860. Afterwards, he stayed on at his ranch in Deep Creek, later moving to Salt Lake City, where he died in 1878. (Courtesy Daughters of Utah Pioneers.)

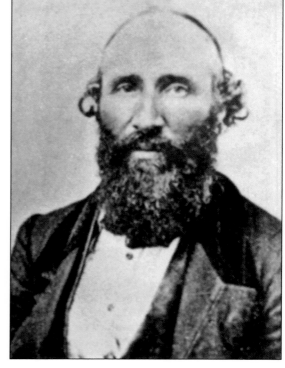

Ephraim K. Hanks was born in Madison, Lake County, Ohio, in 1826. He joined the Church of Jesus Christ of Latter-day Saints in 1845 and left Nauvoo, Illinois, in 1846 with Brigham Young. He served in the Mormon Battalion, arriving in the Salt Lake Valley in 1847. He was a mail carrier in the early 1850s and established a way station at Mountain Dell, east of Salt Lake City, which served as a Pony Express relay station. Hanks was known for his skill as a frontiersman and his loyalty to his church. He died at his ranch in Wayne County, Utah, on June 9, 1896. (Courtesy Utah State Historical Society.)

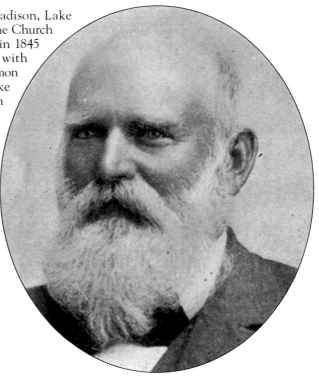

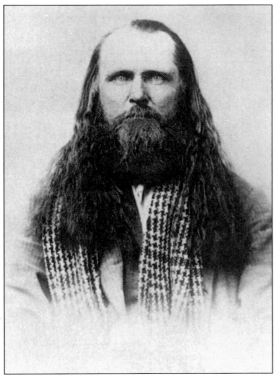

Orrin Porter Rockwell was born in June 1813 in Belchertown, Massachusetts. He joined the Church of Jesus Christ of Latter-day Saints at age 16, and, in the early days of the church, acted as bodyguard for the Mormon prophet Joseph Smith. According to legend, he was promised by Joseph that, if he never cut his hair, his life would never be taken by bullet or blade. After the exodus to Utah, he served as a lawman famed and feared for relentless pursuit and swift justice. Rockwell operated the Hot Springs Brewery & Hotel at the southern end of the Salt Lake Valley, where a swing station for the Pony Express was located. He was a well-known and controversial figure on the Utah frontier. Porter Rockwell died of natural causes in Salt Lake City on June 9, 1878. (Courtesy Utah State Historical Society.)

The romantic image of a young rider on a fleet horse racing across the plains has long been a favorite for artists in a variety of media. In this drawing, the galloping rider salutes a passing wagon train. The piece celebrates the initial run of the Pony Express and its arrival in Salt Lake City on April 7, 1860. (Courtesy Utah State Historical Society.)

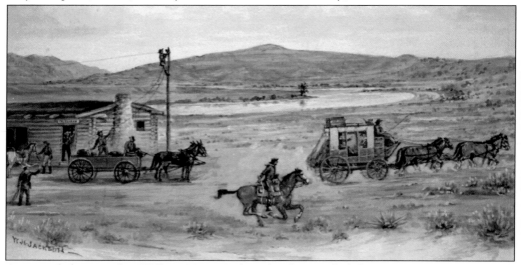

Artist and photographer William Henry Jackson has been called the "Picture Maker of the Old West." In this painting, Jackson featured a freight wagon, stagecoach, telegraph workers stringing wire, and a Pony Express rider leaving the station. He painted a number of such composites, depicting the progress and settlement of the West. Included in many is a small representation of one of his favorite subjects, the Pony Express rider. (Courtesy Scotts Bluff National Monument.)

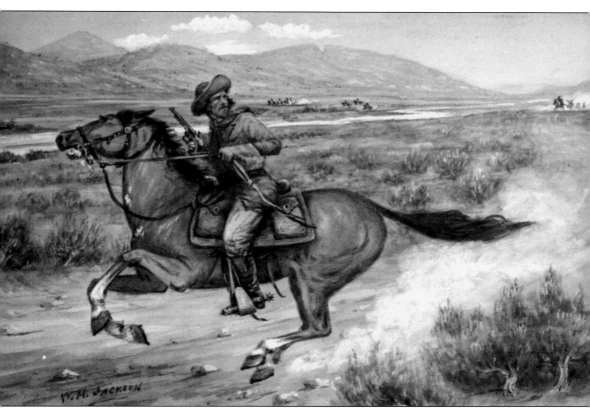

William Henry Jackson painted this classic Pony Express rider. Jackson was born in Keeseville, New York, in 1843. He came west as an ox-team driver in 1866, having served in the Union Army in 1862. His important photographic subjects include the 1869 Transcontinental Railroad, Yellowstone Park, and Mesa Verde. Most of his prolific painting was done in the 1930s, when Jackson was past 90 years of age. He died in 1942 at age 99. (Courtesy Scotts Bluff National Monument.)

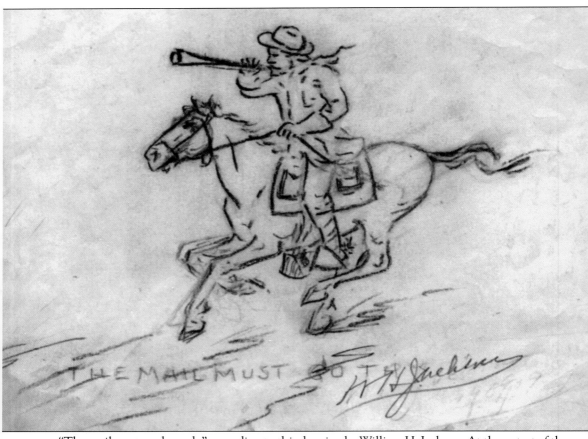

"The mail must go through," according to this drawing by William H. Jackson. At the outset of the Express mail service, riders were said to have carried a horn that they blew to alert the station folk of their arrival. They reportedly carried one or two Colt revolvers and a light carbine. Horn and carbine were soon discarded, and the rider's baggage was lightened to include only one Colt .36 revolver, with perhaps an extra loaded cylinder. (Courtesy Scotts Bluff National Monument.)

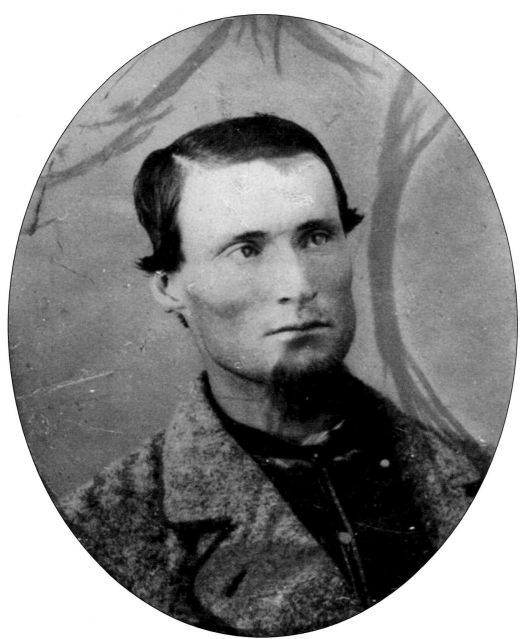

Howard Ransom Egan, the son of Maj. Howard Egan, was born on April 12, 1840, making him 21 years old when the Pony Express made its first run. Although listed in some sources as an alternate rider, Howard Ransom apparently had a number of opportunities to carry the Pony Express mail, and he recounted stories of some thrilling experiences as a rider. He lived at Deep Creek, where his father's ranch was located, then moved to Richmond, Utah, where he farmed and operated a sawmill. He died of pneumonia on March 17, 1916. (Courtesy Utah State Historical Society.)

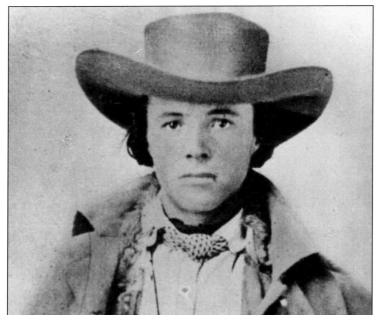

Richard Erastus "Ras" Egan was a handsome 18-year old Pony Express rider in 1860. The son of division superintendent Howard Egan, Ras carried the first westbound mochila out of Salt Lake City on April 9, 1860. He covered 75 miles in 4.5 hours on that first trip. After his days as a rider, Egan farmed in present-day Nevada and, later, in Wyoming. He served many years as a bishop in the Mormon Church and died in Byron, Wyoming, in 1918. (Courtesy Daughters of Utah Pioneers.)

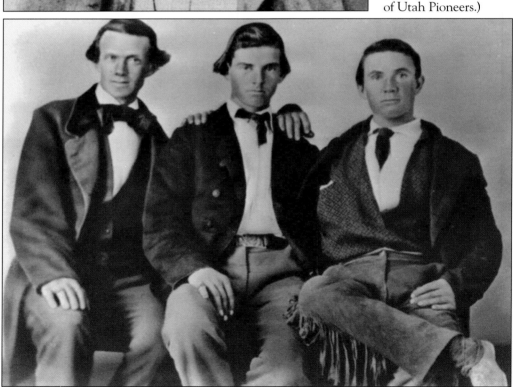

British-born brothers William (left) and John Fisher (center) were shining examples of the dashing young Mormons who rode for the Pony Express in Utah Territory. They are pictured here with a friend, John Hancock, who had no known connection with the Pony. (Courtesy Daughters of Utah Pioneers.)

John Fisher, seen here in later years, was born in Woolwich, Kent County, England, and immigrated to the United States in 1854. He rode for the Pony on routes west from Salt Lake City to Roberts Creek in present-day central Nevada. After the Express, he drove stagecoaches, then settled down to farm and raise livestock in Bountiful, Utah. He died in October 1905 at age 63. (Courtesy Daughters of Utah Pioneers.)

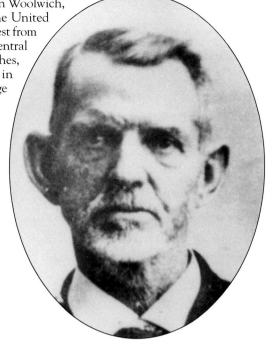

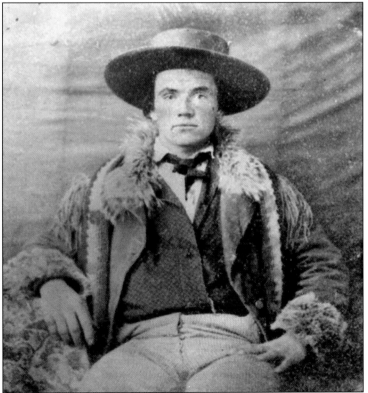

William Frederick Fisher, older brother of John Fisher, was born in November 1839 in Woolwich, Kent County, England. His family emigrated in 1854. Fisher was an Express rider west from Salt Lake City and also in present-day Nevada. He carried the news of Lincoln's election in the record-breaking relay ride. He later became a farmer and stockman in Ruby Valley, Nevada, then Bountiful, Utah. Fisher spoke the Shoshone language. He died in September 1919. (Courtesy Daughters of Utah Pioneers.)

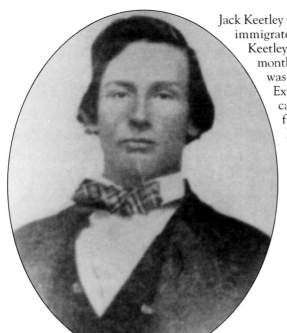

Jack Keetley was born in 1841 in England, and his family immigrated to the United States in the late 1850s. Keetley was a Pony Express rider for the entire 19 months of the mail service, serving in Kansas. He was known as "the Joyous Jockey of the Pony Express." After the close of the Express, Keetley came to Utah, where he became a prominent figure in mining. The small mining town of Keetley, near Park City, is named in his honor. He died in Salt Lake City in October 1912. (Courtesy Daughters of Utah Pioneers.)

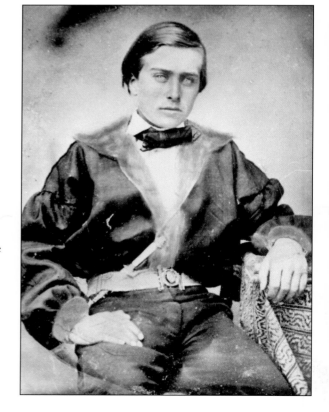

Thomas Owen King was born in 1840 in Dernford, Cambridgeshire, England. His family came to the United States and Utah in 1853. King carried mail and express for the Brigham Young Express Company before the days of the Pony. He carried Pony Express mail between Weber Station and Fort Bridger. King ranched and farmed mainly in southern Idaho until his death in 1921. He poses here with a stiletto-type knife, in which he seems to take considerable pride. (Courtesy Daughters of Utah Pioneers.)

William Page was born in 1838 in Birmingham, England, and came to Utah in 1856 with the ill-fated Martin handcart company. As a Pony rider, he carried the mail east from Salt Lake City. He was later a farmer in Bountiful, Utah, where he was active in local politics. He died suddenly in 1893 at age 54. (Courtesy Daughters of Utah Pioneers.)

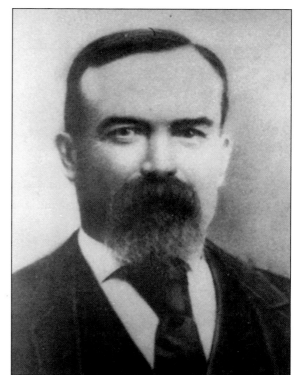

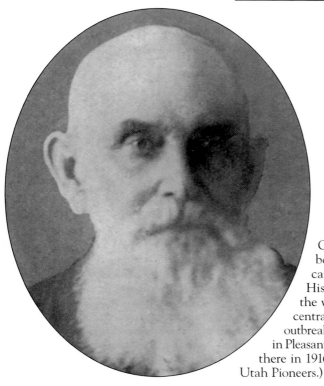

George Washington "Wash" Perkins, born in Hancock County, Illinois, came to the Salt Lake Valley in 1849. His Pony Express route was mostly in the western part of Utah Territory, now central Nevada. He carried the news of the outbreak of the Piute War. Perkins later lived in Pleasant Green (now Magna), Utah, and died there in 1916 at age 80. (Courtesy Daughters of Utah Pioneers.)

Guglielmo Sangiovanni was born in London, England, in 1835. He came to America as a child with his mother, and never saw his father again. Sangiovanni was very well educated, and after his service with the Pony Express, he edited a small newspaper in St. George, Utah. He also worked as a freighter all across the West. He died in Salt Lake City in 1915. (Courtesy Daughters of Utah Pioneers.)

George Washington Thatcher came to Utah with his family as a boy at the age of seven in 1847. He carried the Pony Express mail west out of Salt Lake City. He told the story of being attacked by a wolverine while walking his horse through deep snow. Thatcher later served as mayor of Logan, Utah, where he died in 1902. (Courtesy Daughters of Utah Pioneers.)

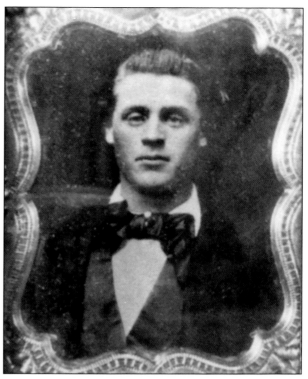

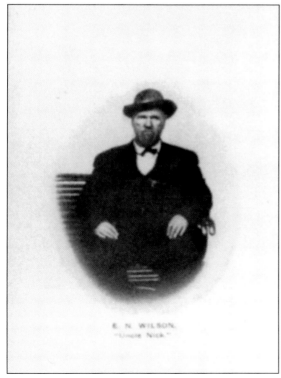

Elijah Nicholas Wilson, known as "Uncle Nick" in his later years, lived with the Shoshone Indians for a couple of years before returning to Utah and signing up as a Pony Express rider. He had some thrilling adventures as a rider in Utah's west desert; Wilson always wore a hat to cover a scar inflicted by an Indian arrow. The town of Wilson, Wyoming, where he died in 1915, is named in his honor. (Courtesy Daughters of Utah Pioneers.)

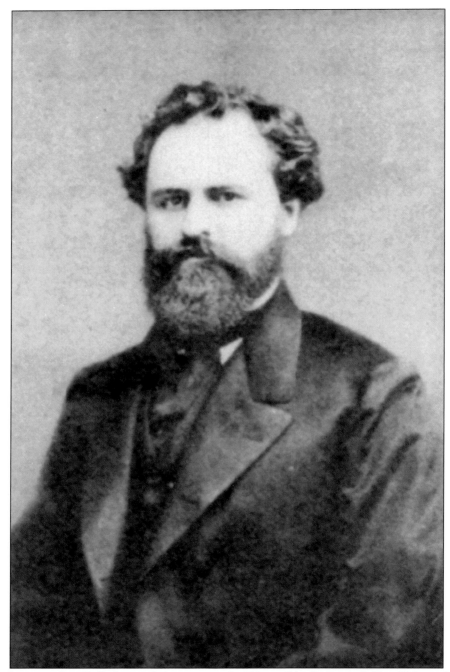

Kentucky native Ben Holladay was known across the West as "the Stagecoach King." He established the stage line to California for Gold Rush–bound travelers in 1849. As a friend of Brigham Young, he built a prosperous business hauling freight to Salt Lake City. In 1861, when financial difficulties drove Russell, Majors & Waddell to dissolution, Holladay took over from them the Central Overland California & Pikes Peak Express Company, which had operated the Pony Express. (Courtesy Daughters of Utah Pioneers.)

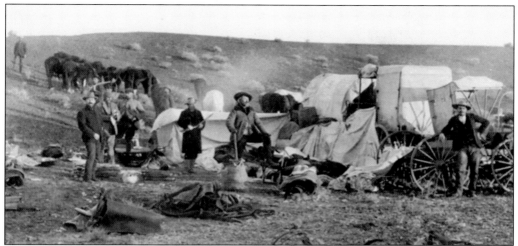

William F. Cody, "Buffalo Bill," always claimed to have ridden for the Pony Express. Although his close relationship with Alexander Majors is undisputed, most historians today feel that his case for having carried Pony Express mail is not a strong one. Still, Buffalo Bill featured the Pony Express in his Wild West Shows performed around the world, and he was instrumental in keeping the memory of "the Pony" alive. He is shown at center in the above photograph, at a hunting camp on the plains in the late 1880s. (Above, courtesy Utah State Historical Society; right, courtesy Library of Congress)

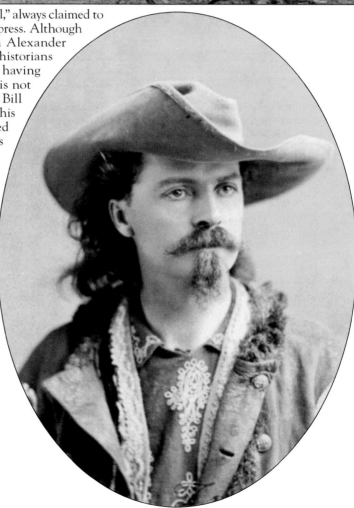

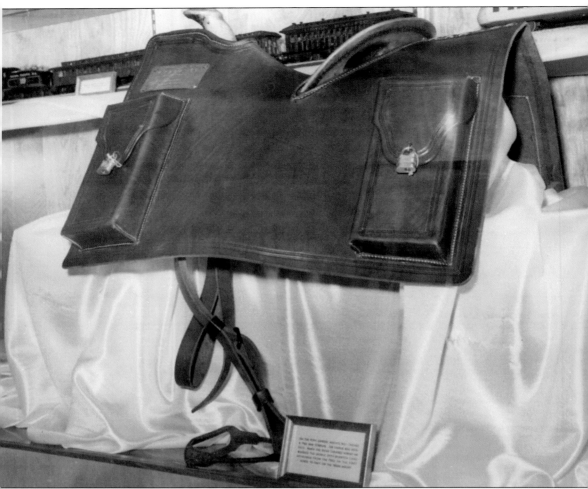

Pony Express mail was carried in a mochila similar to the one shown here, displayed in the Daughters of Utah Pioneers Museum in Salt Lake City. It consisted of a flat piece of leather with holes cut out for the saddle horn and cantle. It was thrown over a lightweight saddle and could be removed and changed to another saddle and horse in a few quick motions. Mail was carried in four pockets, or cantinas, sewn to the corners. The right front pocket was called the "way pocket." Keys to the way pocket could be found along the route, to add or remove letters as needed. The other three pockets were locked for the duration of the trip between St. Joseph and Sacramento. Israel Landis of St. Joseph is said to have been the saddle maker for the Pony Express. (Courtesy Utah State Historical Society.)

Three

PONY EXPRESS
HOME STATIONS

Each express rider was assigned a run of approximately 75 to 100 miles, which he covered with a change of horses every 10 to 20 miles. The stations where they lived between mail runs, called home stations, were most often located in cities or towns, or at larger, well-established ranches. The rider's job was to carry the mochila from one home station to the next, and there, turn it over to the next rider. He would then wait for the mail in the other direction, and return.

Present-day Utah was home to three, and possibly four, home stations. Easternmost was Weber Station, established and operated by James Bromley. Weber Station was located at the head of Weber Canyon, at its junction with Echo Canyon coming in from the north and east. The town that sprang up around Bromley's ranch and enterprises was called Echo.

Salt Lake City was a logical location for a home station, the riders lodging at the hotel known as Salt Lake House. It must have been a choice assignment for the Pony riders, with its downtown city location and the coming and going of travelers of every sort and from every locale. The young and handsome riders must have been popular with travelers and citizens alike.

About 75 miles south and west of Salt Lake City was Henry Jacob Faust's Rush Valley Station. Doc Faust, as he was called, raised horses, hay, and grain to be shipped to more remote stations in western Utah. Faust's ranch, though without the luxury of Salt Lake House, was still a comfortable and important stop on the stage and express line in Rush Valley.

Fish Springs Station, named for the numerous small fish that live in the warm springwater of the area, is named in most sources as a Pony Express home station. The water, abundant, though warm and somewhat brackish, made Fish Springs an attractive resort for Indians from prehistoric times and a logical place for a ranch and express station. About 20 miles farther west along the trail stands Willow Springs Station, now in the village of Callao. The Bagley family, on the ranch at Willow Springs since the late 1800s, learned the early history of the area from those who experienced it firsthand. They assert that Willow Springs served the Pony Express as a home station. The Pony was a pragmatic and dynamic operation, and it is easy to imagine that both Fish and Willow Springs Stations were called home stations at different times during the run of the mail service.

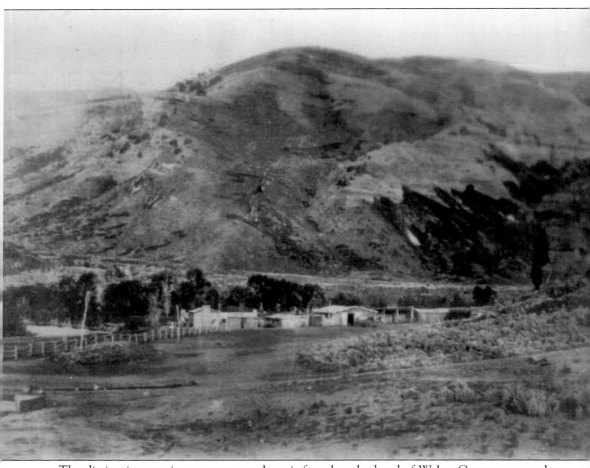

The distinctive curving canyon seen here is found at the head of Weber Canyon, near where Echo Creek enters the Weber River. The town of Echo, as well as the Weber Pony Express and Stage Station, were built in this area. (Courtesy Daughters of Utah Pioneers.)

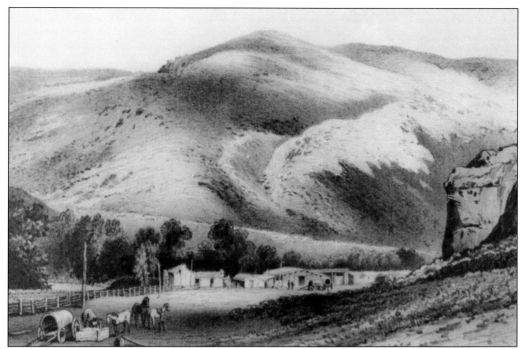

This drawing depicting the head of Weber Canyon shows the curve of the canyon, which catches the eye as one looks west from the town of Echo. It must have been a notable landmark on the trail in the 1800s. (Courtesy Utah State Historical Society.)

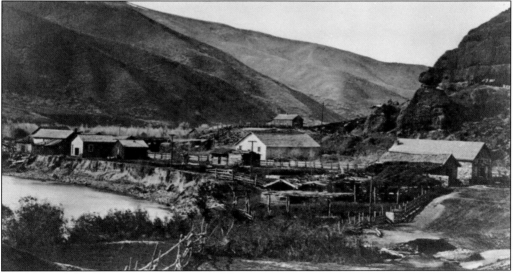

James Bromley built and operated the Weber Stage and Pony Express Station at the mouth of Echo Canyon. Cate Carter describes the station as a stone structure, built in 1853, with walls 26 inches thick. The stone building at right in this photograph bears a signboard for J.E. Bromley & Co., and may be that station building. Horace Greeley, traveling through in 1859, spent the night at Weber Station and noted the presence of two "groceries," a blacksmith's shop, and the mail station. (Courtesy Utah State Historical Society.)

This monolith, which stood in front of Pulpit Rock, was an important landmark on the Mormon Pioneer, Pony Express, and California Trails. It stood at the mouth of Echo Canyon, where Echo Creek empties into the Weber (pronounced "Weeber") River. Pulpit Rock was destroyed during the construction of US Highway 30. (Courtesy Curtis Brent Moore collection.)

Echo City, located where Echo Canyon empties into Weber Canyon, was a thriving concern in the late 1800s, especially after the coming of the railroad. These ladies pose on the hillside north of the town in 1868. In the background are the town, Pulpit Rock, and James Bromley's store. (Courtesy Utah State Historical Society.)

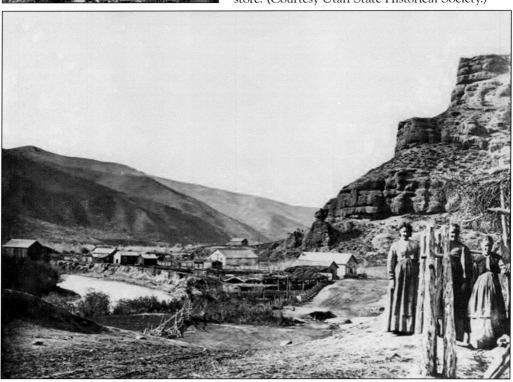

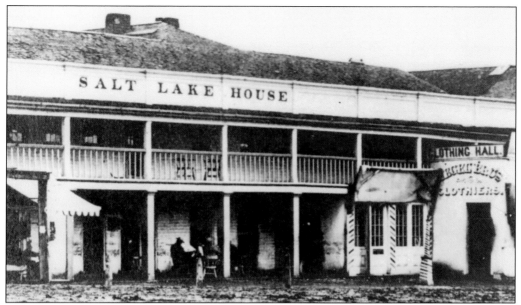

Salt Lake House, located on Main Street (East Temple Street in the early days) in Salt Lake City, was the principal establishment for accommodation of travelers to the city. Sir Richard Burton, who often found little to praise on the Western frontier, lodged there in 1860. He remarked that he had "not seen aught so grand for many a day." Burton, Sam Clemens, and other well-known figures of the day lodged at Salt Lake House while visiting Great Salt Lake City or passing through. (Courtesy Utah State Historical Society.)

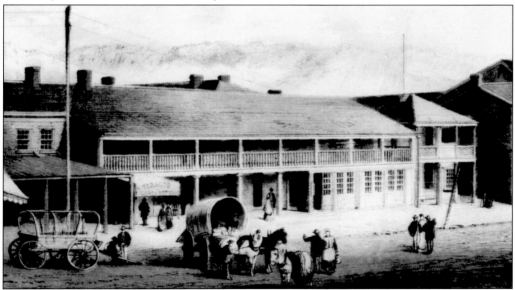

This drawing depicts "Salt Lake Hotel—Wasatch Mountains in the Distance" as it appeared around 1860. Although Pony Express mail was probably handled at the express office across the street, Salt Lake House provided accommodations for Pony Express riders and company officials. As such, it meets the definition of a Pony Express home station. (Courtesy Utah State Historical Society.)

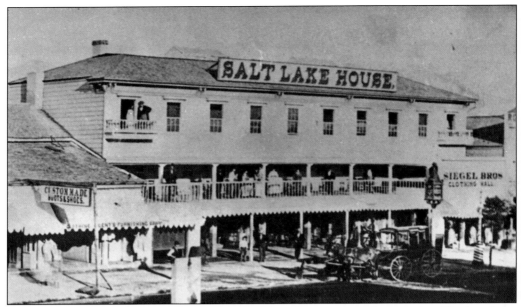

Shown here with a carriage in front, Salt Lake House has grown to three stories. The hotel was established by Brigham Young, who wished to provide comfort and a favorable impression for travelers to Salt Lake City. In addition to serving as a Pony Express home station, it undoubtedly also served the Overland Stage. (Courtesy Utah State Historical Society.)

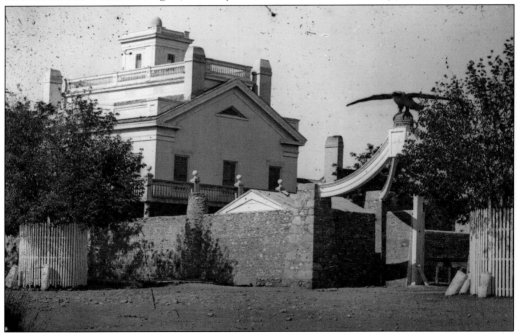

Salt Lake City landmarks that would have been familiar to Express riders in 1860 included Brigham Young's Beehive House and Eagle Gate. The Eagle Gate, featuring a carved wooden eagle, was erected in 1859 at the entrance to Young's property. A bronze eagle can be seen atop today's Eagle Gate over State Street at South Temple Street. (Courtesy LDS Church History Library.)

The foundation of the Salt Lake LDS Temple would have been a familiar site to both residents and visitors to downtown Salt Lake City, including Pony Express riders, in 1860. The cornerstone for the temple was laid on April 6, 1853, and the building took 40 years to complete. (Courtesy LDS Church History Library.)

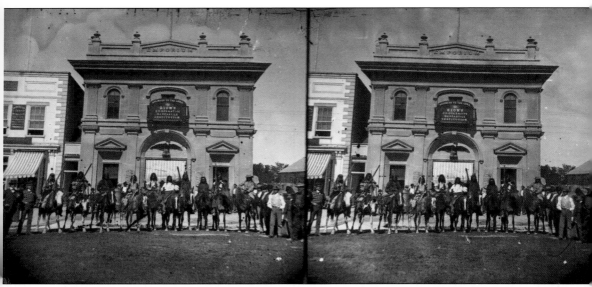

In this stereopticon image, a band of armed and mounted Indians pose in front of the Zion's Co-operative Mercantile Institution building in downtown Salt Lake City for photographer C.W. Carter. Express rider Howard R. Egan galloped through an Indian camp on the trail in a narrow canyon, firing his gun in the air. He later learned from a friendly Indian that they wanted to stop him to find out what he was carrying and why he rode so fast. (Courtesy LDS Church History Library.)

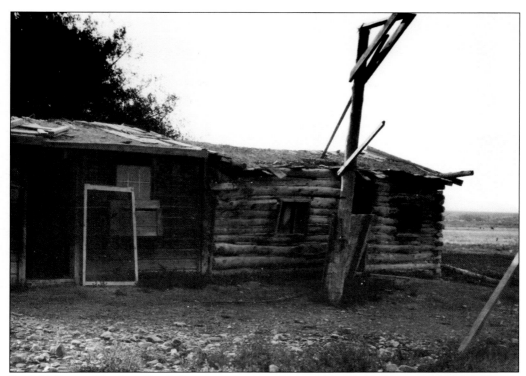

Rush Valley, or Meadow Creek Station was built and operated by Henry Jacob "Doc" Faust. It was the first home station for the riders west of Salt Lake City. British author and explorer Sir Richard Burton stopped here on his journey west in 1860. He describes Faust as "a civil and communicative man, who added knowledge of books and drugs to the local history." Doc Faust homesteaded 160 acres of meadowland in Rush Valley, raising horses and growing hay, which supplied the more remote Pony Express stations in the west desert. (Courtesy Utah State Historical Society.)

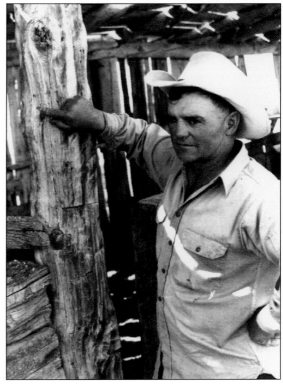

The Old West was often a rough and tumble place. Sometimes, evidence exists of incidents about which historians would love to know more. Here, Pierre Castagno points to a bullet hole in a post at the old Rush Valley Pony Express Station, where his wife, Cosetta, played as a child. (Courtesy Roseann Castagno McPhaul).

Because it had abundant water, Fish Springs was a logical site for pioneer settlement and ranching. James H. Simpson describes a thatch-roofed shed at Fish Springs in 1859, but other sources say that the station and stable, which served the stage and Pony Express, were built of stone. The stone buildings in this Charles Kelly photograph were mostly a part of the John Thomas ranch, established in the late 1880s. The buildings were removed in the 1930s. The name Fish Springs derives from the numerous small fish found in the warm and slightly brackish springwater. (Courtesy Utah State Historical Society.)

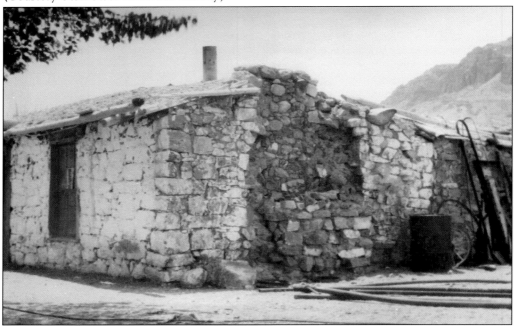

Fish Springs Station probably served as a home station for Pony riders during at least a portion of the run of the Pony Express. The station keeper was a man named Smith. These crumbling ruins may be the remains of the station. But, as with other sites, decades of use for a number of purposes make it difficult to appeal to historic photographs for the location or description of the station. (Courtesy Utah State Historical Society.)

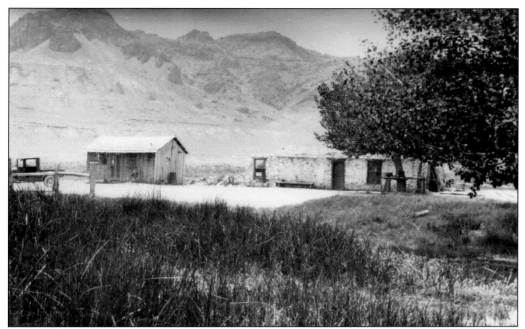

The Pony Express station at Fish Springs was located at the House Spring, near the trees in this photograph. Historically, the springs were an important water source for the Indians of the area, and they continue to serve as a vital oasis on the migration routes of thousands of birds of dozens of species. (Courtesy Utah State Historical Society.)

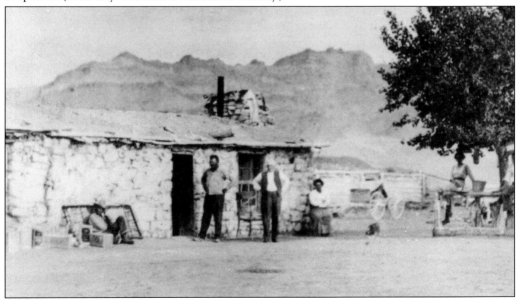

This 1914 photograph shows the Wells Fargo Station on John Thomas's ranch at Fish Springs. The location, about equidistant between Rush Valley and Deep Creek, provided welcome water and shade for emigrants, stage passengers, Pony riders, and travelers on the Lincoln Highway. The transcontinental telegraph also followed this route in 1861. (Courtesy Utah State Historical Society.)

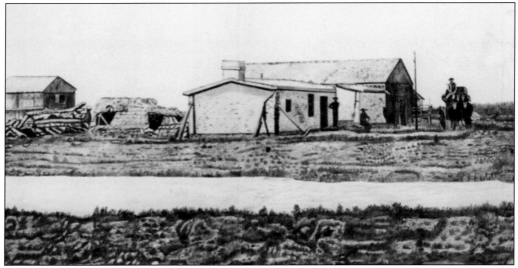

Francis L. Horspool left this drawing of Willow Springs Station, now in the village of Callao, Utah. The station still stands on Willow Springs Ranch. The Bagley family, who have been on the land for more than a century, describe Willow Springs as a Pony Express home station that also provided meals and accommodations to travelers on the stage route. Richard Burton was entirely unimpressed with the cleanliness of the station, but he spoke favorably of the hospitality offered. (Courtesy Dr. Joseph L. Hatch collection.)

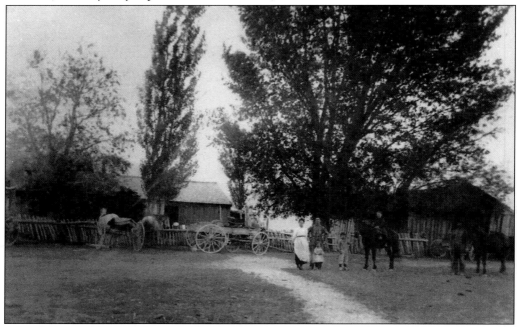

After the run of the Pony Express, Willow Springs Station continued to serve the overland stage as well as smaller local stage lines well into the 20th century. By 1900, when this photograph was taken, the original adobes of the station on the Bagley Ranch had been protected with a covering of wood. The exact location of the large barn shown in the Horspool drawing is unknown. (Courtesy Charles Bagley.)

Four

SWING, OR
RELAY STATIONS

The program called for lightweight riders on horses chosen for speed and endurance. The Pony Express Company provided horses of better quality, which were better fed than those of the Indians and most bandits, and the riders were instructed to run rather than fight if pursued. But even the most enduring of mounts has a limited range, so relay, or swing stations were placed at intervals between the more-established home stations. Initially, the swing stations were located from 20 to 25 miles apart, but additional stations were added when that distance often proved too great. Horses were changed about every 10 miles in many areas.

In more settled parts of the country, relay stations were located at established ranches or places of public accommodation, such as Mountain Dell and Rockwell's Stations. In more remote regions, stations had to be built, and living conditions for the station keepers were often harsh and primitive. British explorer Richard Burton described Dugway Station in 1860 as "a mere 'dug out'—a hole four feet deep, roofed over with split cedar trunks, and provided with a rude adobe chimney." Provisions for the station men, feed for livestock, and even water had to be hauled considerable distances. Of life at these isolated outposts, Burton reported, "It is a hard life, setting aside the chance of death . . . the work is severe; the diet is sometimes reduced to wolf-mutton, or a little boiled wheat and rye, and the drink to brackish water."

The station keepers and stock tenders at the swing stations had the responsibility to have a horse saddled and waiting upon the arrival of an Express rider, who would change the mochila from one horse to another in two minutes. Employees at swing stations in the west desert had to be able to endure isolation and solitude, as well as the danger from marauding Indians.

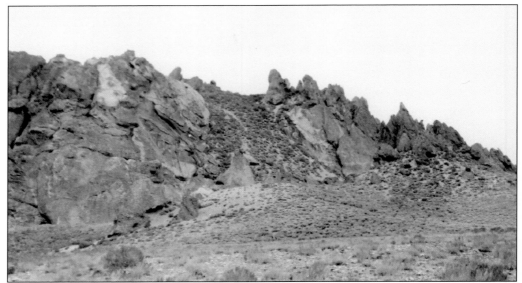

This Charles Kelley photograph shows Needle Rocks, or The Needles, a well-known landmark on the Mormon Pioneer and Pony Express Trails. Located on Yellow Creek just west of the present-day Utah-Wyoming border, this impressive pudding-stone formation overlooks the site of the Needle Rocks Pony Express Station. (Courtesy LDS Church History Library.)

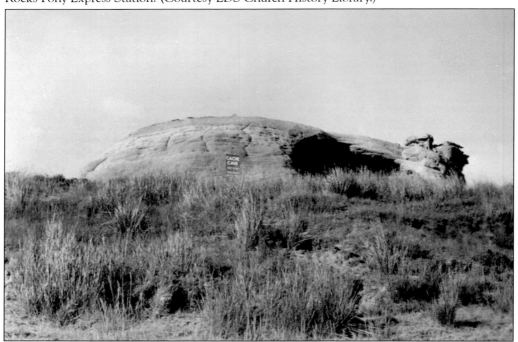

Cache Cave was another well-known landmark on the emigrant trail in Utah. It was also known as Redden's Cave, having been discovered by Return Redden Jackson in 1847. Numerous emigrants and travelers inscribed their names on the walls inside the cave. Some historians have postulated that Cache Cave may have been used as a Pony Express relay station for a time. (Courtesy Utah State Historical Society.)

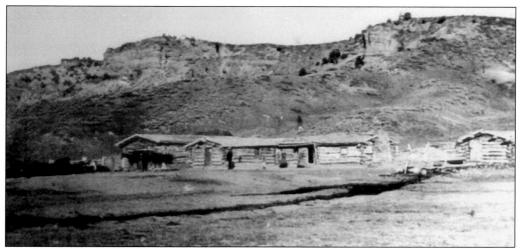

One of the notable rock formations in Echo Canyon is Castle Rock. The express station located at the foot of the cliffs was also known as Castle Rock, Head of Echo, or Frenchie's Station. As with many Pony Express stations, the location of this facility has been the subject of some debate. Research and interviews with longtime residents of the area have convinced the authors that the buildings and spring seen in this A.J. Russell photograph were found at the authentic Castle Rock site. (Courtesy Curtis Brent Moore.)

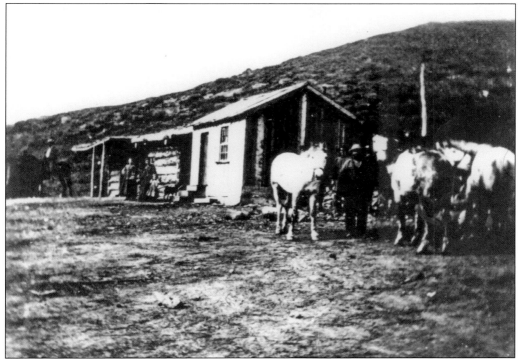

Hanging Rock, or Halfway Station was located about halfway down Echo Canyon. It was also known as Daniels' Station, named after the station keeper, a Mr. Daniels. The "hanging rock" for which the station is named is a stone arch or bridge just down-canyon from the station. (Courtesy Curtis Brent Moore.)

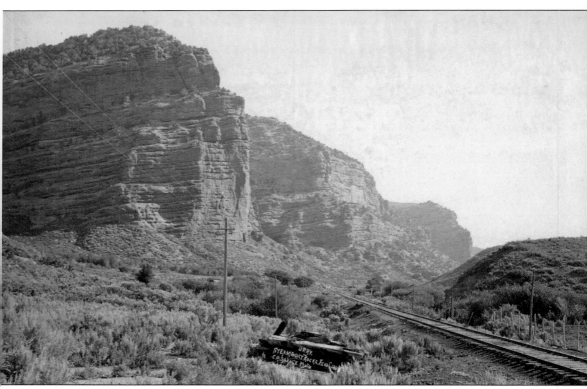

Echo Canyon has long been noted for its spectacular rock formations. Sir Richard Burton, traveling through in 1860, wrote, "Echo Canyon has but one fault: its sublimity will make all other similar features look tame." Steamboat Rock stands a little way up-canyon from Bromley's Weber Stage and Pony Express Station. (Courtesy Utah State Historical Society.)

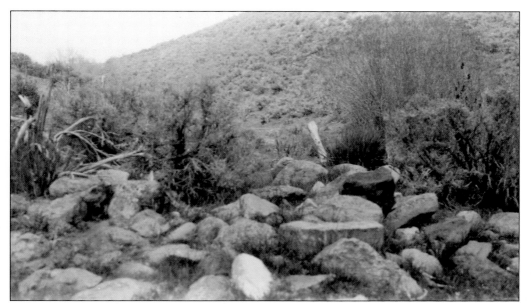

Dixie, or Dixie Creek Station was located in Dixie Hollow. Although the actual location has been debated, a rock alignment indicating a building foundation can be seen near this pile of rocks. Also, farrier tools and horseshoes and mule shoes have been found just to the south of the rock pile, at the probable location of the stock corral. (Courtesy Utah State Historical Society.)

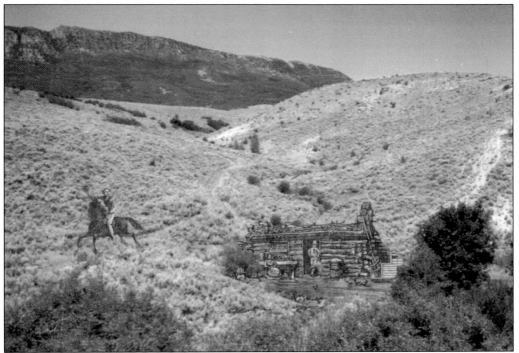

Historian John Eldredge has added a station and Pony Express rider to this photograph of Dixie Hollow. The cabin is located at the original station site. The rider salutes with a wave of his hat as the station keeper stands in the door, watching his departure. (Courtesy John Eldredge.)

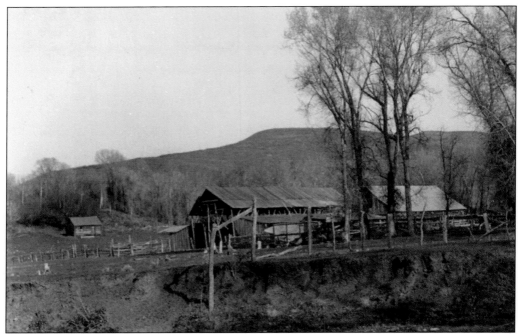

Bauchmann's Station, located on East Canyon Creek east of Salt Lake City, was used by both stagecoach lines and the Pony Express. It was also known as East Canyon Station, Carson House, and sometimes, "Dutchman's Flat" by some who could not remember the name of the station keeper, Bauchmann. The station was a small log cabin (left) located near a water source called Pig Spring. (Courtesy Dr. Joseph L. Hatch.)

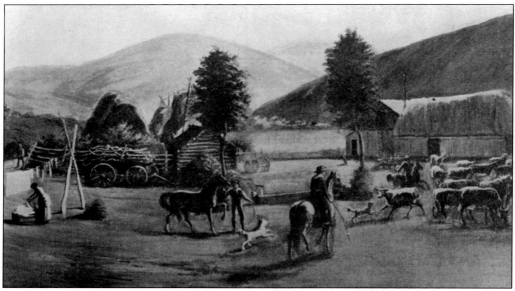

Mountain Dell, or Hanks' Station was established in 1858 and operated by Ephraim Hanks, a prominent figure on the Mormon frontier. This painting of Mountain Dell was done by Norwegian-born pioneer artist Danquart Wegeland, who has been called "The Father of Utah Art." (Courtesy Dr. Joseph L. Hatch.)

For the first few weeks of the Pony Express service, snow was too deep over Big Mountain for the ponies to travel that way. Snyder's Mill, built in 1853 in Parley's Park by Samuel Snyder, served as a relay station for the change of horses during those early runs. The rider continued on Parley P. Pratt's Golden Pass Road, meeting up with the original trail at Weber Station. (Courtesy John Eldredge.)

The first relay station on the road south out of Salt Lake City was Travelers' Rest, or Traders' Rest. By the time this photograph was taken, the adobe building had been covered with wood and a false front was added. It had been used for a variety of businesses in the days since the Pony Express. (Courtesy Dr. Joseph L. Hatch.)

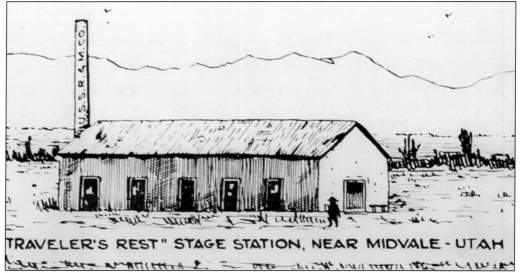

TRAVELER'S REST" STAGE STATION, NEAR MIDVALE - UTAH

This drawing depicts " 'Travelers' Rest' Stage Station near Midvale—Utah." This relay station was built fairly late in the era of the Pony Express mail service. It was located at what was known as Lovendahl's Corner, south of Salt Lake City. The station keeper was Absalom Smith. (Courtesy Dr. Joseph L. Hatch.)

This is an 1875 drawing of Orrin Porter Rockwell's Hot Springs Brewery & Hotel, located near Point of the Mountain at the southern end of the Salt Lake Valley. Porter Rockwell was one of the most colorful characters in frontier Utah, having served as bodyguard for the Mormon prophet Joseph Smith and church president Brigham Young. Rockwell also served as a frontier lawman, known and feared for his relentless pursuit and swift and final justice. (Courtesy John Rockwell.)

The adobe barn shown here in a photograph by Edward M. Ledyard was a part of Rockwell's Hot Springs Brewery & Hotel, which also served as a Pony Express relay station. The design was similar to the horse barn at the Colorado Stables in Salt Lake City, also owned by Rockwell. (Courtesy Dr. Joseph L. Hatch.)

The station located near the divide between Utah and Cedar Valleys was run by Joe Dorton. Known as Joe's Dugout, or simply Dugout, the station consisted of a two-room house built of brick or stone, a large log barn, and a small store. The name stems from a log-roofed dugout built by Dorton for an Indian boy he had hired as a stable hand. This Edward M. Ledyard photograph shows a well dug at Dorton's establishment. At a depth of more than 350 feet, no water had been found, and water for the station had to be hauled in casks from Utah Lake. (Courtesy Dr. Joseph L. Hatch.)

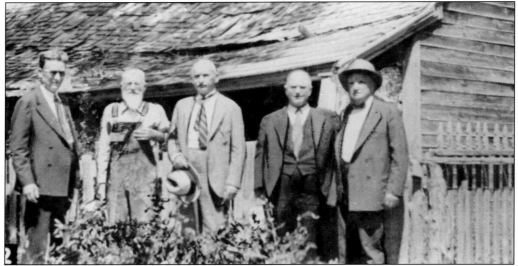

John Carson erected a two-story building made of adobe with a wooden facade in Fairfield, Utah, in 1858. The building, which was home to Carson's family, also served as an inn for travelers. Carson Inn was known as an oasis of decency in a wide-open town of rowdy camp followers attached to Camp Floyd (Frogtown, as it was called, boasted 17 saloons in 1860). The building was owned and maintained by the Carson family into the 1940s, but it rapidly fell into disrepair after being abandoned. Shown here are, from left to right, Dr. W.M. Stookey, W. Carson, Dr. Leo W. Middleton, S.O. Bennion, and Joseph Wirthlin. They stand in front of the dilapidated building. Carson Inn, now Stagecoach Inn, has been restored and stands as the centerpiece of Camp Floyd/Stagecoach Inn State Park. (Courtesy Utah State Historical Society.)

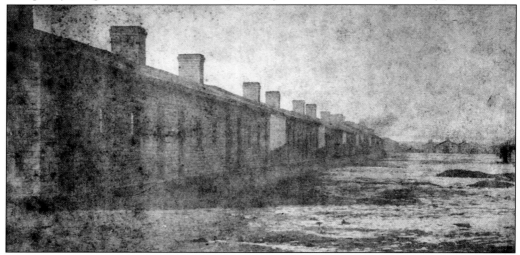

In 1858, a contingent of nearly 3,000 US Army troops entered Utah. They had been sent the previous year by Pres. James Buchanan to quell a purported "Mormon uprising" in Utah. By negotiated settlement, the soldiers moved to the village of Fairfield, about 45 miles south and west of Salt Lake City. They named their post Camp Floyd, for Secretary of War John B. Floyd. The name was later changed to Fort Crittenden when Floyd defected to the Confederacy. This 1859 photograph shows the headquarters and ordnance buildings at Camp Floyd. (Courtesy Utah State Historical Society.)

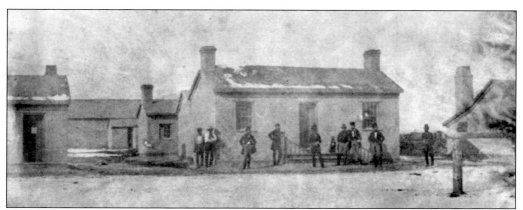

Gen. Albert Sydney Johnston commanded the "Army of Utah" at Camp Floyd in 1858. Col. Phillip St. George Cooke assumed command when Johnston resigned his commission to join the Confederate army. The US Army was recalled to the East in 1861 when the Civil War broke out (the orders were delivered by Pony Express). This January 1859 photograph shows the commanding general's quarters. This building, along with the rest of the camp, was razed when the Army departed Utah. (Courtesy Utah State Historical Society.)

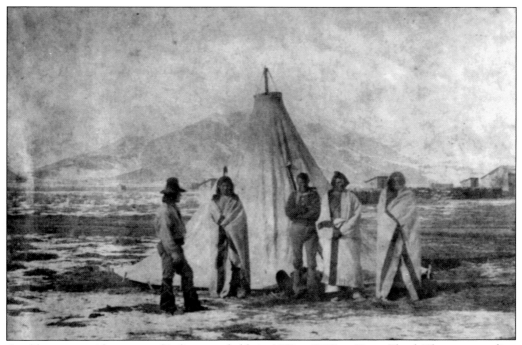

A soldier poses with a group of Indians, probably in 1859 or 1860, at Camp Floyd. They are standing in front of a Sibley tent, a simple conical tent that enjoyed considerable popularity in the West. The design was patented by American military officer Henry Hopkins Sibley in 1856. The tent was held down by pegs and featured a unique cowl over the center pole to allow ventilation and an escape of fire smoke during cooking. (Courtesy Utah State Historical Society.)

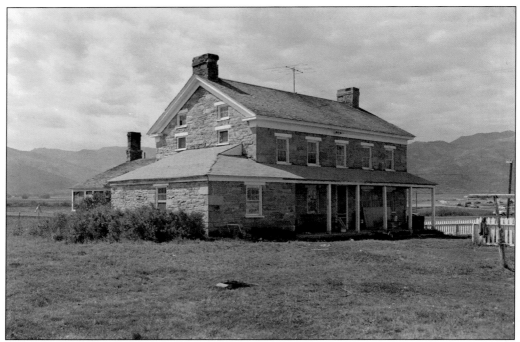

Kimball's Stage Station was built by Hiram Kimball in 1862. Though constructed too late to serve the Pony Express, it was an important stop on the overland stage line at Kimball's Junction in Parley's Park. The building housed a hotel and the first saloon in the Park City area. (Courtesy John Eldredge.)

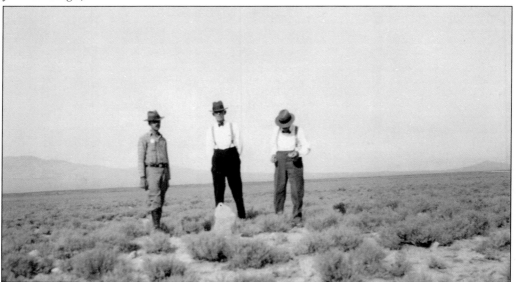

Pass, or No-Name Station, where these men stand in a Charles Kelly photograph, was located about midway between Camp Floyd and Rush Valley, or Meadow Creek Station. Little is known about the station; very likely, little activity took place here. A stone marker constructed by the Civilian Conservation Corps (CCC) is found at this spot in east Rush Valley. (Courtesy Utah State Historical Society.)

Known today as Lookout Pass, this area was called General Johnston's Pass in 1860, named for Camp Floyd commandant Gen. Albert Sydney Johnston. From the pass and Jackson's Station, the riders and other travelers could look west into Skull Valley and the desert land known as Piute Hell. This photograph was taken by W.M. Stookey. (Courtesy Utah State Historical Society.)

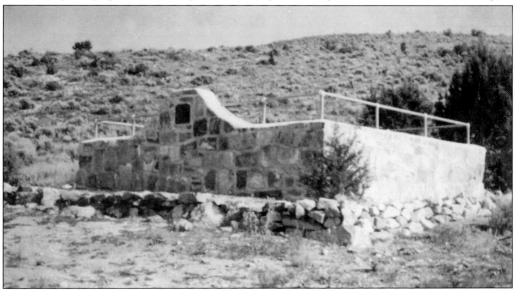

A curiosity along Utah's Pony Express Trail is Libby Rockwell's dog cemetery. Beginning in the late 1860s, Horace Rockwell, brother of Orrin Porter Rockwell, and his wife, Libby, moved to a small log house in Lookout Pass. The couple had no children, and "Aunt" Libby, as she was called, kept several small dogs on which she lavished every care. She had a stone enclosure built as a burial place for her beloved dogs when they died. In addition, three immigrant's graves are said to lie within the walls. (Courtesy Utah State Historical Society.)

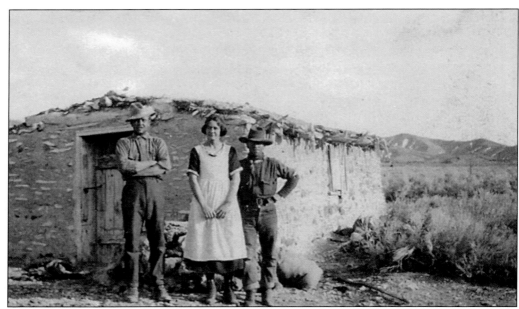

These hardy-looking folks stand in front of a pioneer home built by Dewey and Clara Anderson at Simpson Springs. It stood just south and east of the old Pony Express station. Clara Anderson died in childbirth in 1895, and may never have lived in the home. The stone ruins of the Anderson home have been stabilized by the Bureau of Land Management and can be seen inside a chain-link enclosure north of the Simpson Springs campground. (Courtesy Roseann McPhaul.)

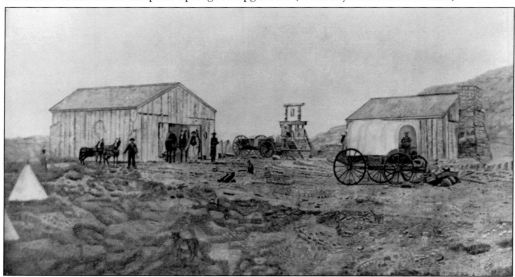

This Francis L. Horspool drawing depicts the Wells Fargo station at Riverbed. Its caption reads, "River Bed Stage Station of Wells Fargo & Co. It was haunted by failure, so is this canvas." The stage employees claimed that the site was haunted by "desert fairies," making it hard to keep the station staffed. In this drawing, William F. Horspool, father of Francis, is shown holding horses at the corner of the stable. Riverbed Station was probably built in late 1861, too late to have served as a station for the Pony Express. A rock CCC monument was placed here nonetheless. (Courtesy Dr. Joseph L. Hatch.)

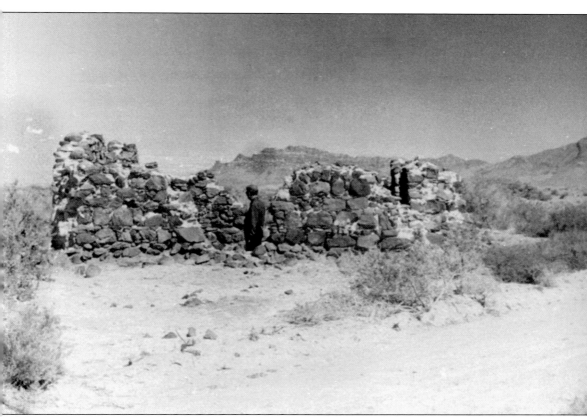

Boyd's Station was also called Butte, or Desert Station, or possibly Salt Wells. Located in Snake Valley on the west side of the Fish Springs Mountains, it was built by and named for George Washington Boyd about 1855. The photograph shows the ruins of a one-room stone cabin that served as station house. The building is said to have been constructed with gun ports in all four walls. Bunks were built into the walls, and furniture consisted of boxes and benches. (Courtesy Utah State Historical Society.)

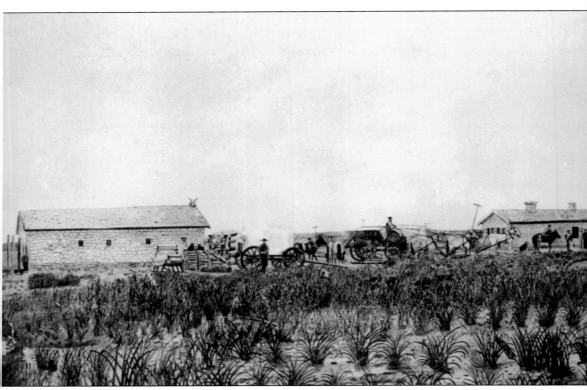

Francis L. Horspool's drawing shows Deep Creek Station on the ranch of Maj. Howard Egan. Egan may have visited the Deep Creek country as early as 1852, but he established his ranch and mail station there in 1859. Sir Richard Burton described the ranch and station as "two huts and a station house, a large and respectable-looking building of un-burnt brick, surrounded by fenced fields, watercourses, and stacks of good adobe." Although the station served the stagecoach line, the relay station for the Pony Express may have been located about two miles south. (Courtesy Dr. Joseph L. Hatch.)

Five

COMMUNICATION AFTER THE PONY EXPRESS

Even as the Pony Express was speeding letters across the continent with a rapidity Americans had not seen before, the transcontinental telegraph line was being extended from both east and west to provide even faster communication. As the telegraph line reached further west across the plains, and further east across the Great Basin, the runs of the Pony Express became shorter, until, on October 24, 1861, the telegraph lines were joined and the fabled Express slipped into obsolescence. This original telegraph line was soon eclipsed by a multi-line telegraph, built in 1869 along the route of the new Transcontinental Railroad. Completion of the railroad on May 10, 1869, provided the welding link of steel rails across the continent and brought to an end the pioneer era in Utah and the West.

But the spirit of man is restless, looking always to cross the next frontier. With the invention of the telephone, messages sent by Sam Morse's code and the telegraph became a thing of the past. By 1914, voice messages transmitted from coast to coast by telephone had become possible. Speed of delivery of letter mail, newspapers, parcels, and merchandise also accelerated in the early 20th century. The railroad network, popularization of the automobile, and the advent and advancement of travel and transportation by air all served to promote the communication that contributed to the settlement of the West.

The advancement of technology has continued to provide means for faster and more convenient communication. Mobile telephones and pagers have given way to cellular phones and instant-messaging systems. E-mail and social media, facilitated by computer technology, put people in touch with friends and family at a speed their pioneer forbears could never have imagined. The communication advances of the 21st century can only be imagined.

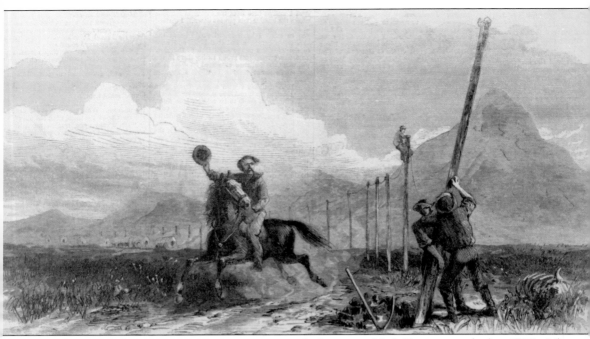

George M. Ottinger was a prominent artist and educator in Utah Territory in the late 1800s. Like many other artists, he was attracted to the Pony Express. In this drawing, Ottinger shows the Express rider saluting, with a wave of his hat, the linemen setting telegraph poles as the end of the Express draws near. The Ottinger drawing was photographed by his business partner, Charles R. Savage. (Courtesy Dr. Joseph L. Hatch.)

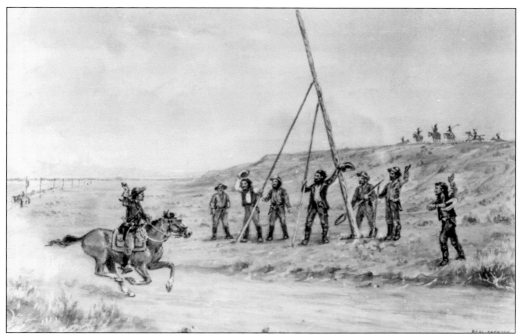

Artist and photographer William Henry Jackson's paintings depict the Pony Express riders in about every situation. They are seen leaving stations, pursued by Indians, crossing wintry streams, and, here, waving a salute to the workers on the transcontinental telegraph. Did the rider know that the completion of the telegraph would put an end to the Express? (Courtesy Scotts Bluff National Monument.)

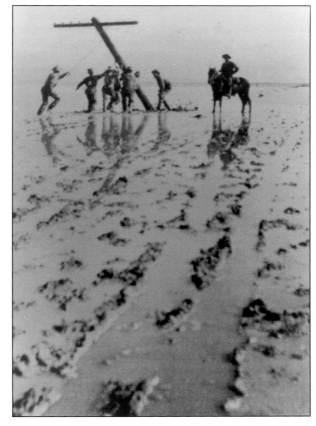

Workers struggle to erect a telegraph pole in the mud of western Utah in 1869. The first transcontinental telegraph, completed in 1861, brought rapid communication between East and West and made the Pony Express obsolete. The Express was the last long-distance mode of communication relying on flesh and blood. Since then, the world has witnessed a cascade of technological advances, leading to the instant-message delivery of today. (Courtesy Utah State Historical Society.)

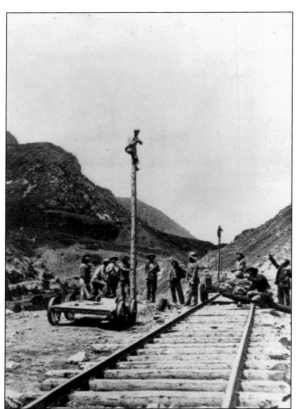

A.J. Russell photographed these telegraph workers atop newly erected poles in 1869. The telegraph is being run in Weber Canyon, east of Ogden, Utah, and parallel to the recently completed Union Pacific Railroad line. (Courtesy Utah State Historical Society.)

On May 10, 1869, the Transcontinental Railroad was completed at Promontory Summit, just north of the Great Salt Lake in Utah. At 12:30 p.m., a symbolic golden spike was driven by former California governor Leland Stanford and Union Pacific Railroad vice president Thomas Durrant. This painting by Thomas Hill, entitled *The Driving of the Golden Spike at Promontory*, depicts the event. Dignitaries attending the event, including Stanford and Durrant, can be identified in the painting. (Courtesy Utah State Historical Society.)

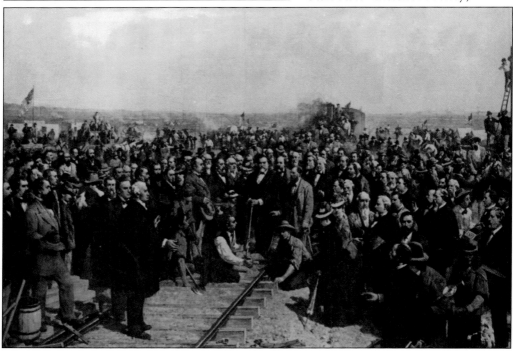

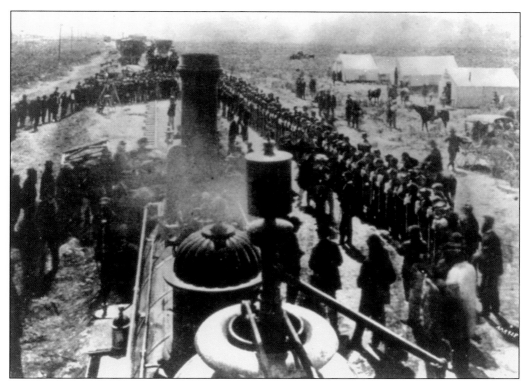

After six years of construction, the last spike on the Transcontinental Railroad was driven at Promontory Summit, Utah, on May 10, 1869. This photograph by Alfred A. Hart was taken from the Union Pacific's engine No. 119. Here, four companies of soldiers from the 21st Infantry stand beside the Central Pacific engine *Jupiter*. (Courtesy Utah State Historical Society.)

Promontory Town was a short-lived settlement that existed for a time near the site of the completion of the Transcontinental Railroad. Such transient towns, often called "Hell on Wheels" towns, sprang up at numerous points along the growing railroad line, only to be torn down and moved a few miles to the next point at the end of the tracks. They were generally filled with some pretty unsavory characters, providing liquor, gambling, "soiled doves," and anything else aimed at separating track workers from their wages. (Courtesy Utah State Historical Society.)

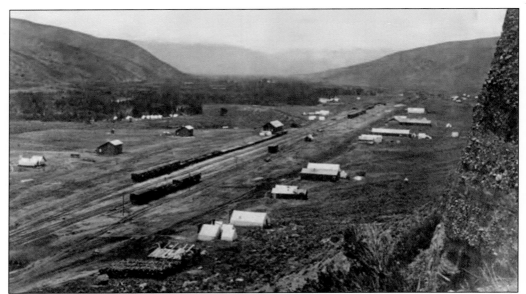

The Transcontinental Railroad, which ran through Echo Canyon and proceeded down Weber Canyon, was built by the Union Pacific Railroad Company. The Central Pacific Company built simultaneously from the west, meeting on Promontory Summit on May 10, 1869. The coming of the long-anticipated railroad provided a link between the coasts and truly opened the West for settlement and commerce. Here, the railroad goes through the city of Echo. (Courtesy Utah State Historical Society.)

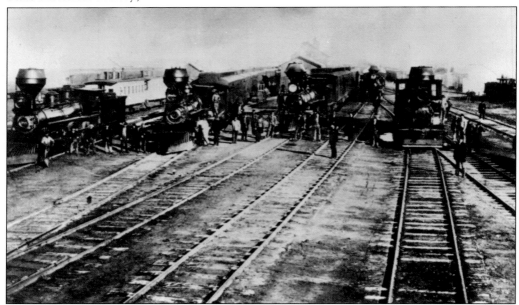

This 1887 photograph of the Ogden railroad yards shows the steam locomotives of the era. On the left are engines of the Union Pacific Railroad, and in the center is the Central Pacific's Old No. 14. The first railroad line in 1869 ran down Weber Canyon and into Ogden, then west to Promontory. Spur lines were soon built to serve Salt Lake City, the territorial capitol. (Courtesy Utah State Historical Society.)

A steam locomotive is shown here in 1870 from the bluffs above Pulpit Rock and Echo City. The completion of the railroad at Promontory Summit in northern Utah brought an official end to the pioneer era in Utah. (Courtesy Curtis Brent Moore.)

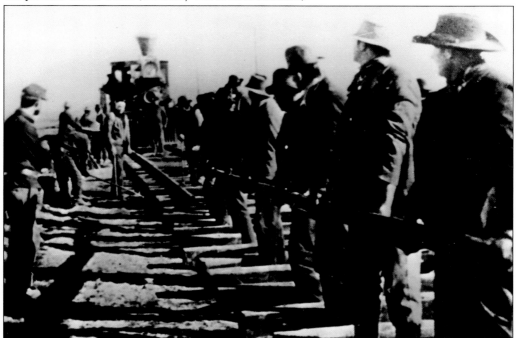

The amount of manpower required to complete the Transcontinental Railroad was truly amazing. Large numbers of Irish immigrants worked on the Union Pacific line, while most of the effort for the Central Pacific was provided by Chinese laborers. On April 28, 1869, Central Pacific track crews laid a record-setting 10 miles of track in one day west of the Promontory Mountains in Utah. (Courtesy Bureau of Land Management.)

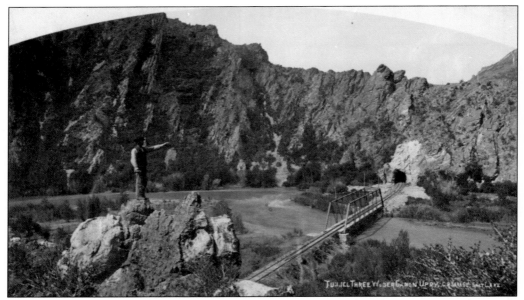

Weber Canyon was so rugged that some early immigrants in 1846 found it necessary to dismantle wagons to negotiate the canyon. The building of the Transcontinental Railroad required immense work and remarkable engineering. Among the projects was the construction of tunnels, such as the one shown in this Charles Savage photograph. (Courtesy LDS Church History Library.)

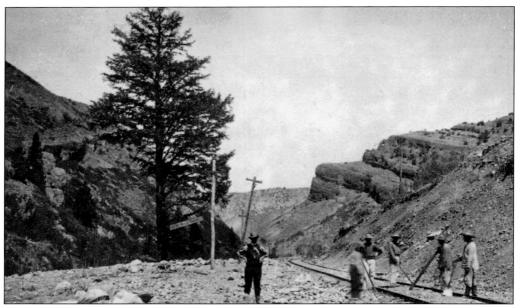

Photographer Charles R. Savage captured this image of "the 1,000-Mile Tree" with a railroad track gang in Weber Canyon. In January 1869, construction workers discovered that this tree on the bank of the Weber River was exactly 1,000 miles from Omaha, Nebraska, the eastern terminus of the first Transcontinental Railroad. (Courtesy LDS Church History Library.)

Some spectacular scenery and rock formations can be found in lower Weber Canyon. Devil's Slide consists of two parallel slabs of limestone, 40 feet high and 25 feet apart, extending several hundred feet down the canyon wall. It remains a notable landmark in the canyon today, as it was in the early days of the railroad. (Courtesy LDS Church History Library.)

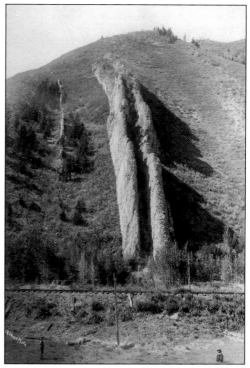

A.J. Russell photographed these Mormon surveyors in the Uinta Mountains in 1869. The Mormon people and the resources of Utah were tremendously important to the completion of the Transcontinental Railroad. Mormon laborers helped prepare the road beds, and most of the ties for the western part of the Union Pacific line were cut from the lodgepole pine forests on the north slope of Utah's Uinta Mountains. (Courtesy Utah State Historical Society.)

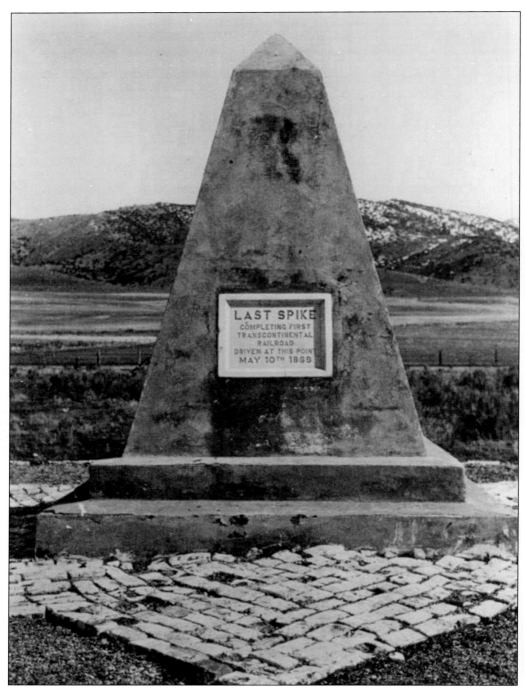

This monument was erected at Promontory Summit, Utah, in honor of the completion of the Transcontinental Railroad near there on May 10, 1869. The last spike, or "golden spike," was driven with a silver hammer, celebrating the final link in 1,907 miles of contiguous railroad track stretching between Council Bluffs, Iowa, and the San Francisco Bay in California. (Courtesy Utah State Historical Society.)

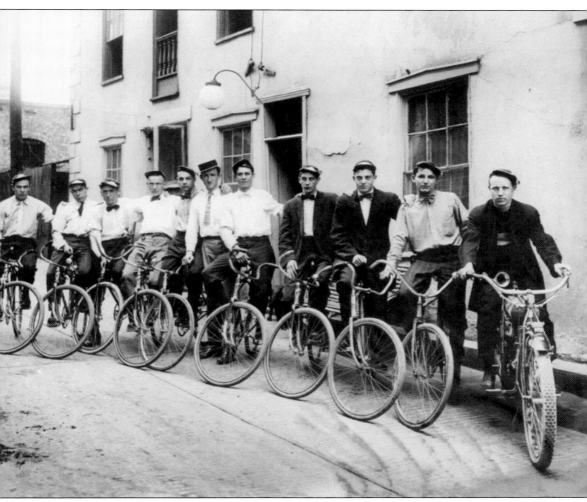

One mark of civilization is the desire to receive information and news quickly. Seen here in 1912, these special district messenger boys on bicycles were employed to expedite telegraph messages. (Courtesy Utah State Historical Society.)

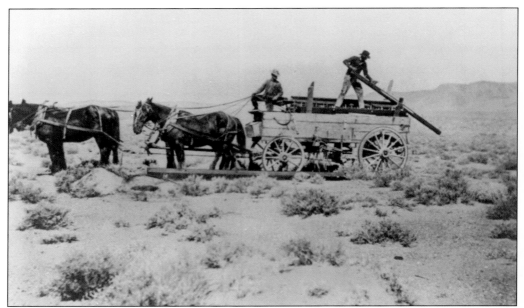

Alexander Graham Bell patented the first practical telephone in 1876, and America and the world witnessed the spread of communication to the next level. Little more than 50 years after the click of the telegraph first sent messages across the continent, voice communication between New York and San Francisco became possible. This 1914 photograph shows workmen distributing poles for construction of the first transcontinental telephone line. (Courtesy Utah State Historical Society.)

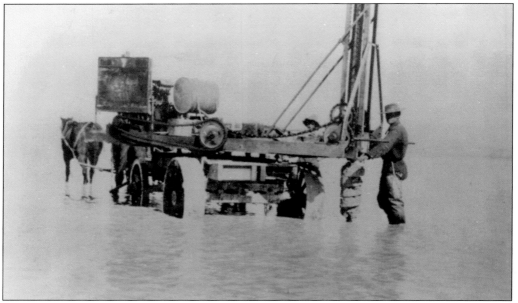

Workmen use a wagon-mounted machine to set telephone poles for the first transcontinental telephone line. Wet conditions and alkali mud in the Great Basin made line construction in the spring of 1914 difficult. Completion of the project required the stringing of 4,750 miles of telephone line. (Courtesy Utah State Historical Society.)

The last pole on the transcontinental telephone line between New York City and San Francisco was erected on June 17, 1914, at the Utah-Nevada state line, at Wendover, Utah. Voice communication was now possible between the East and West Coasts. Message delivery by Pony Express was only a little more than 50 years in the past. (Courtesy Utah State Historical Society.)

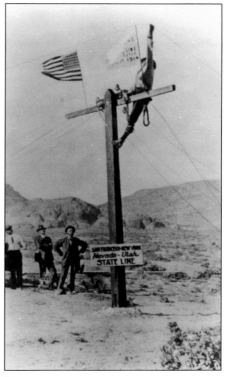

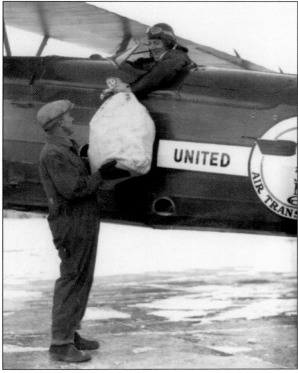

The advent of the airplane signaled another leap forward in the transportation of letters and parcels. Here, an aviator receives a mailbag from a worker on the ground in 1930. (Courtesy Utah State Historical Society.)

By 1930, the US Mail was carried rapidly and efficiently by planes, such as the one shown here. By the end of the decade, transatlantic flights had become fairly routine for the delivery of mail and merchandise. (Courtesy Utah State Historical Society.)

Six

PONY EXPRESS
COMMEMORATIVE RE-RIDES

The idea of riding the Pony Express Trail had an attraction throughout much of the 20th century, and this fascination continues today.

The first Pony Express re-ride took place in the late summer of 1923. Pres. Calvin Coolidge sent a signal from Washington, DC, to St. Joseph, Missouri, to set the re-ride in motion. The event appears not to have followed the trail of the original Pony Express, entering Utah from the east on Highway 50 & 6, and exiting to the west on the old Highway 40 at Wendover. It was estimated that 40 riders and approximately 247 horses were involved.

The 1935 Diamond Jubilee Re-ride celebrated the 75th anniversary of the historic Pony Express and the 25th anniversary of the Boy Scouts of America. Approximately 300 Boy Scouts acted as Express riders. The 1935 ride, conducted from west to east, seems to have followed the original trail. The Utah Pioneer Trails and Landmarks Association put on celebratory events as the mail passed through Utah.

Plans for the celebration of the Pony Express's centennial in 1960 were put in motion as early as 1957. The governors of all eight states crossed by the trail were involved, with Utah governor George D. Clyde playing a key role and Pres. Dwight D. Eisenhower serving as honorary chairman of the National Pony Express Centennial Association. A two-way re-ride of the trail was organized, leaving St. Joseph and Sacramento simultaneously on July 19, 1960. The extensive celebration included placement of markers and monuments, production of a memorial medallion, a 4¢ postage stamp, and memorabilia of every sort. It was a fitting 100th-anniversary event.

Following the centennial celebration, Judge Sherrill Halbert of California encouraged local horsemen to perpetuate the idea of a Pony Express Re-ride. As a result, the National Pony Express Association (NPEA) was incorporated in California in 1978, and in 1980, the organization conducted its first re-ride of the entire trail between St. Joseph and Sacramento. The NPEA put on a two-way ride in 1985 for the 125th anniversary and an impressive series of events, including a re-ride, for the 150th anniversary in 2010. As of this writing, NPEA has organized and executed 35 annual re-rides of the Pony Express National Historic Trail, so named since 1993. Utah riders and supporters look forward to a continuation of this tradition.

David C. Bagley (far left) and Mark Tripp ride away from some young local "Indians" in Callao, Utah, during the 1935 Pony Express Re-ride. The Oregon Trail Memorial Association sponsored the relay ride for the Pony Express Diamond Jubilee. Riders were Boy Scouts. David Bagley, 14, rode from Willow Springs Station in Callao to Boyd's Station, making the fastest time of any rider during that event. (Courtesy Beth Bagley Anderson.)

In 1957, the governors of the eight states crossed by the historic Pony Express met to formulate plans for its 100th anniversary. Here, Utah governor George D. Clyde holds a plaque designed by Perry Driggs. These plaques were produced and distributed along the trail as part of the observance of the diamond jubilee. A second distribution followed in conjunction with the centennial celebration. Pres. Dwight D. Eisenhower was named honorary chairman of the National Pony Express Centennial Association. (Courtesy Utah State Historical Society.)

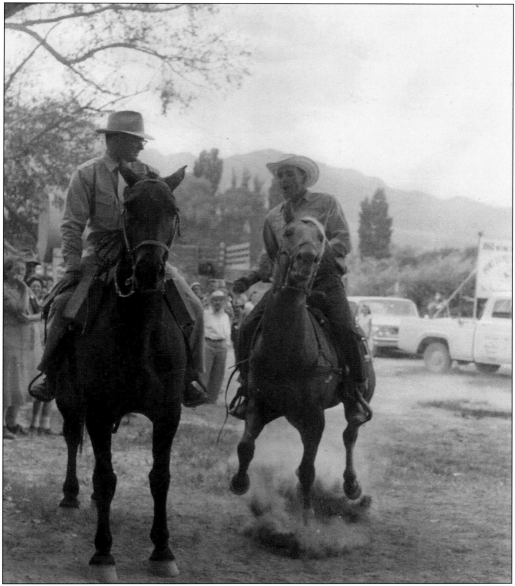

David C. Bagley (left) and Don Denton exchange the mochila at Willow Springs Station in Callao, Utah, during the 1960 centennial celebration of the Pony Express. Bagley holds the distinction of having ridden in the 1935 (diamond jubilee), 1960 (centennial), and 1985 (quasquicentennial, or 125th anniversary) Pony Express Re-rides. (Courtesy Beth Bagley Anderson.)

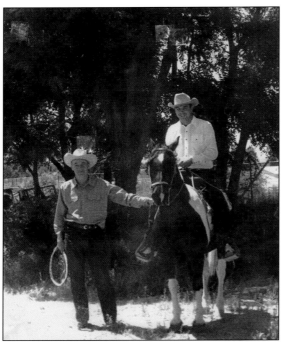

Robert "Cowboy Bob" Lawrence, mounted on his paint horse, awaits the mail pouch during the 1960 Pony Express Centennial Re-ride. The event was conducted across all eight states, with riders traveling in both directions. The eastbound leg of the re-ride passed through Salt Lake City on July 22, 1960; the westbound on July 25, 1960. Cowboy Bob was a native of Grantsville, Utah. (Courtesy Becky Lawrence Kimber.)

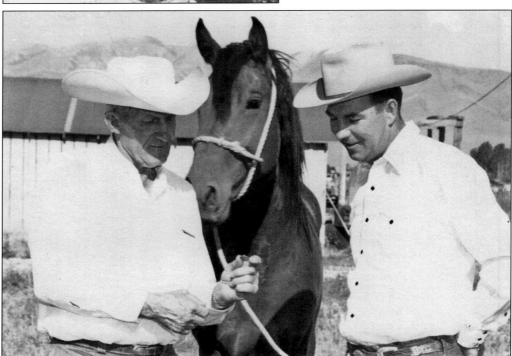

Cowboy Bob Lawrence (right) and Bill Callister admire a medallion presented to Callister for his participation in the 75th Anniversary Re-ride of the Pony Express in 1935. Cowboy Bob is preparing to ride in the 1960 Centennial Re-ride. He rode westbound for five miles in the area of the Utah State Prison. (Courtesy Becky Lawrence Kimber.)

Stewart Paulick (mounted) of
Tooele, Utah, prepares for his ride
during the Pony Express centennial
celebration. His horse is held by
Roland Amos. The celebration
included the re-ride, placement
of bronze plaques, production
of a commemorative coin, and
issuance of a 4¢ postage stamp.
(Courtesy Stewart Paulick.)

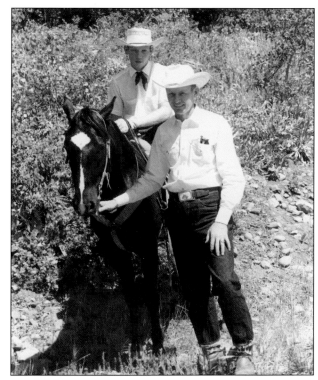

Stew Paulick starts his journey
in the centennial re-ride. He
rode east near East Canyon
Reservoir. The re-ride traveled
in both directions between
St. Joseph, Missouri, and
Sacramento, California, running
from June 19 to June 28, 1960.
(Courtesy Stewart Paulick.)

The National Pony Express Association has conducted a re-ride of the Pony Express Trail between St. Joseph and Sacramento each year since 1980. Approximately 500 horses and riders take part, most carrying the mochila from between two and five miles per ride. Here, Brian Kimber (center) adjusts the mochila as Kellie Hearty prepares for her ride on her quarter horse mare Cheyanne. Robert Lawrence (left) looks on. (Courtesy Patrick Hearty.)

The National Pony Express Association was incorporated in California in 1978 with the mission to identify and mark the Pony Express Trail and to conduct an annual re-ride to keep the spirit alive. Through the efforts of the NPEA, the trail became the Pony Express National Historic Trail in 1993. Here, NPEA's first president, Malcolm McFarland (left), and Utah governor Scott Matheson sign the mochila prior to its departure from Salt Lake City in 1978. The mochila carried commemorative letters with a vignette of Pony Express history. The re-ride started west from Salt Lake City in 1978, from Julesburg, Colorado, in 1979, and ran all the way from St. Joseph in 1980. (Courtesy Patrick Hearty.)

In 1985, to celebrate the Express's 125th anniversary, the National Pony Express Association conducted a two-way re-ride across almost 2,000 miles of the Pony Express Trail. Eastbound mail reached Salt Lake City on June 26, and westbound mail arrived on June 30. Here, Que Christensen (right) and his son Keith make a mail exchange at Simpson Springs during the 1985 ride. (Courtesy Patrick Hearty.)

Patrick Hearty and his horse, Fred, were honored to carry the Olympic torch by Pony Express as it made its way to Salt Lake City for the 2002 Olympic Winter Games. They rode into Fairfield, Utah, and Camp Floyd/Stagecoach Inn State Park on a very frosty February morning. The fife-and-drum corps of the Utah County Civil War Association played for 2,000 to 3,000 spectators, who came out that morning to salute the Olympic flame. (Courtesy Patrick Hearty.)

The National Pony Express Association built a log station (right) and corral for the Western Experience Village at Soldier Hollow near Midway, Utah, during the 2002 Olympic Winter Games. The cabin was moved to This Is the Place Heritage Park following the close of the games. Here, Floyd Hatch swings aboard his father's quarter horse, Sunny, for a leg of the re-ride. (Photograph by Mark Jenkins; courtesy Joseph L. Hatch collection.)

The National Pony Express Association led the way in celebrating the 150th anniversary of the historic mail service, with major sponsorship from the National Park Service and Bureau of Land Management. A kickoff event was held in Washington, DC, adjacent to the US Capitol Building, and a celebratory monument was dedicated in Sydney, Nebraska, featuring flags of all eight trail states, granite monuments, and a world-class bronze statue of a horse and rider done by Heber City, Utah, artist Peter Fillerup. Here, Matt Hearty and his quarter horse gelding Sonny carry the mochila out of Lookout Pass in 2010. (Photograph by Richard Gwin; courtesy National Pony Express Association.)

Diane Workman leads a riderless horse in honor of her grandfather, DeMar Brimhall, as the mail approaches Simpson Springs in the 2010 re-ride. Brimhall, the oldest active rider in the association, planned to participate in 2010 until his death two weeks before. The re-rides are family activities, and it is not uncommon to find three generations of riders carrying the mail. (Photograph by Richard Gwin; courtesy National Pony Express Association.)

NPEA national president Les Bennington of Glenrock, Wyoming, administers the Oath of the Rider to a trio of disabled veterans who took part in the 2010 re-ride near Lookout Pass. Each rider takes an adaptation of the oath that Alexander Majors required of his employees, vowing not to drink intoxicating liquor, use profane language, or quarrel with the other riders. Each rider is presented with a Bible, also following Majors's tradition. (Photograph by Richard Gwin; courtesy National Pony Express Association.)

Raymond Miles (mounted) and Larry Deegan discuss the re-ride route leaving Eagle Mountain, Utah, in 2010. The association works closely with local municipalities and law-enforcement agencies to ensure the safety of riders, horses, and the public. Ham radio operators often accompany the riders on the more remote sections of the trail. (Photograph by Richard Gwin; courtesy National Pony Express Association.)

Fred Leslie and his paint horse Q-Tip begin their ride headed east through Sandy, Utah. The re-ride passing through the metropolitan area of Utah and Salt Lake Valleys faces interesting challenges and hazards. The horses are often shod with special shoes to improve traction when traveling on pavement. Pilot cars may be positioned in front of and behind the rider to help with safe passage in traffic. Road construction and repair schedules may necessitate last-minute route changes. (Photograph by Richard Gwin; courtesy National Pony Express Association.)

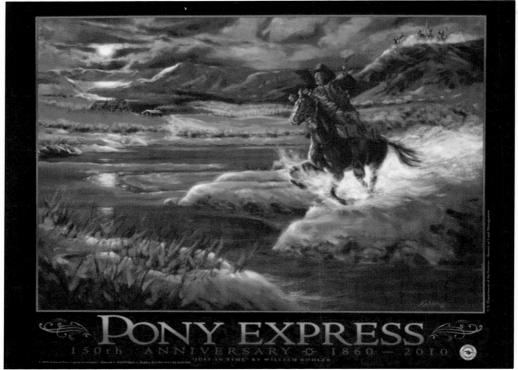

The 2010 Sesquicentennial Pony Express Celebration included a poster honoring the riders. The painting was done by William Kohler of Heber City, Utah. The poster, produced with the support of the Bureau of Land Management, was distributed to members of the public at celebrations across the eight Pony Express Trail states and beyond. (Photograph by Joseph L. Hatch.)

The mustang, symbol of the open West, still runs in Utah's west desert, as it did when the Pony riders traveled that way in 1860. These wild horses run on public lands in western Utah, administered and managed by the Bureau of Land Management. (Photograph by Brian McClatchy; courtesy Patrick Hearty.)

Seven

TRAIL MARKERS, MONUMENTS, STATUES

A debt of gratitude is owed to those who have identified and marked the Pony Express Trail so that others may follow after and learn the history on the ground where the events took place. The most enduring tributes to be found in Utah's west desert are the stone monuments built in the late 1930s and early 1940s by the Civilian Conservation Corps (CCC). These monuments can be seen at or near the location of most of the stations between Camp Floyd and the Utah-Nevada border. Bronze plaques provided by the Utah Pioneer Trails and Landmarks Association were installed on the monuments at the time of construction. The National Pony Express Association (NPEA), through a cooperative agreement with the National Park Service and Bureau of Land Management (BLM), works to maintain these monuments today.

In 1960, the National Pony Express Centennial Association placed attractive bronze markers at This Is the Place Heritage Park and at other significant sites along the trail. During the same period, BLM historians erected cement posts, about three feet in height, bearing the words "Pony Express Trail." The posts are located across most of western Utah on the actual trail, which sometimes differs from the modern road.

Interpretive signs telling Pony Express and other trail history can be found at a number of places along the trail through Utah. Some, such as in Echo Canyon and Henefer, have been provided by local governments and Utah State Parks. Interpretation found at This Is the Place, Faust, Simpson Springs, and at Boyd's and Canyon Stations are courtesy of the National Park Service.

Joe Nardone and his Pony Express Trail Association have installed four-foot-tall, stainless-steel posts at or in the vicinity of most of the stations across the entire trail and informative granite monuments at numerous station sites, including Echo, Eagle Mountain, Camp Floyd State Park, and other locations in Utah.

Most impressive of the trail monuments is the Fairbanks statue at This Is the Place Heritage Park. This beautiful and symbolic bronze sculpture was designed by Dr. Avard T. Fairbanks in 1947. The heroic scale rendition was completed at the park in 1998. A smaller-scale bronze statue honoring the Pony Express can be found at the city hall in Eagle Mountain, Utah.

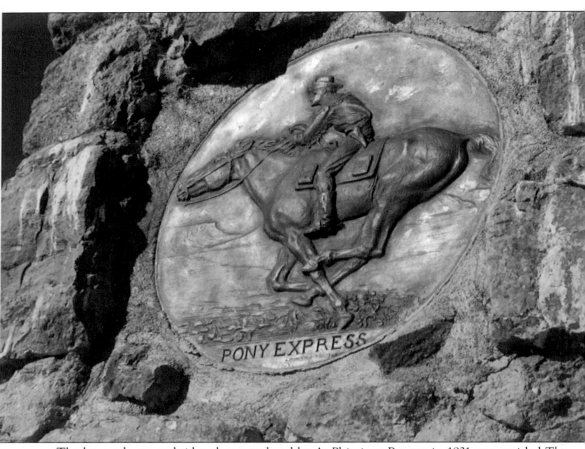

The bronze horse-and-rider plaque sculpted by A. Phimister Proctor in 1931 was entitled *The Spirit of the Pony Express*. It became the standard plaque for markers along the trail. Proctor, a well-known sculptor in the first half of the 20th century, was famous for his accurate portrayal of wildlife and Western subjects. The round bronze plaques, stolen or vandalized over time, are being replaced with a resin substitute with a bronze appearance. The work is being done in Utah by the National Pony Express Association in cooperation with the Bureau of Land Management. (Courtesy Patrick Hearty.)

This Charles Kelly photograph shows the original monument to Rockwell's station, with its round rider plaque designed by sculptor A. Phimister Proctor and a square plaque describing the history of the site. The building of Interstate 15 south out of Salt Lake Valley necessitated the relocation of the monument. A shorter, less-imposing version now stands in a grove of trees at the southeast corner of the Utah State Prison compound. (Courtesy Utah State Historical Society.)

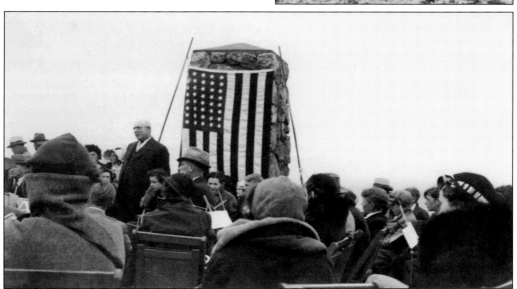

In this photograph from the Charles Kelly collection, M.B. Andrus speaks to a crowd at the dedication of a stone monument commemorating the site of Porter Rockwell's Hotsprings Brewery and Hotel, site of the Pony Express station operated by Rockwell. This event took place on October 13, 1934. (Courtesy Utah State Historical Society.)

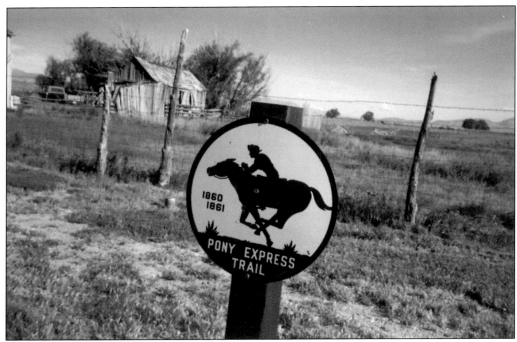

The enameled-steel Pony Express plaque shown here was designed by Utah artist H. Perry Driggs. The plaques were distributed along the trail in 1935, with each state receiving plaques according to the number of miles of trail within their respective borders. A second batch of the Driggs plaques were made during the centennial celebration in 1960–1961. This plaque is located at Camp Floyd/Stagecoach Inn State Park in Fairfield, Utah. (Courtesy Patrick Hearty.)

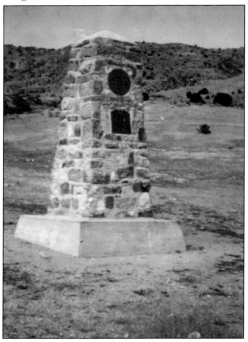

This monument in Lookout Pass (General Johnston's Pass in 1860), photographed by Charles Kelly, is typical of those erected by the Civilian Conservation Corps in western Utah. Frederick W. Hurst, an express company employee, describes a visit to Jackson's station on this site in April 1860. However, in September of the same year, Sir Richard Burton passed "the ruins of an old station" at the same location. Pony Express history is fraught with such contradictions. Lookout Pass is named as a contract station in the 1861 mail contract. (Courtesy Utah State Historical Society.)

This stone monument, found a short distance north of the probable location of the Mountain Dell station, is unique for its tall and triangular shape. When photographed by Charles Kelly, the monument still bore the round rider plaque and the rectangular one commemorating the Pony Express. The visitor today locates it only with difficulty, in a thick grove of small trees. It is stripped of the bronze plaques. (Courtesy Utah State Historical Society.)

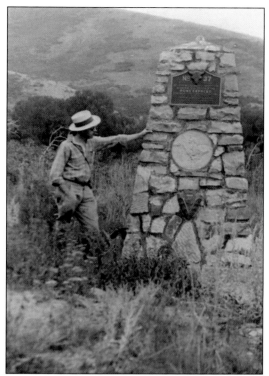

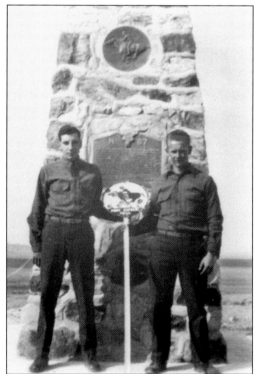

Workmen from the CCC built trails, corrals, and campgrounds, and completed numerous other types of work projects across the West. In Utah, they built stone monuments at the site of each Pony Express station through Tooele and Juab Counties. This Clarence L. Coffman photograph shows two CCC workers standing by the monument at Simpson Springs. They hold a badly shot-up trail sign. A large CCC camp was located at Simpson Springs; probably for that reason, the Simpson monument is the largest and tallest on the trail in Utah. (Courtesy Utah State Historical Society.)

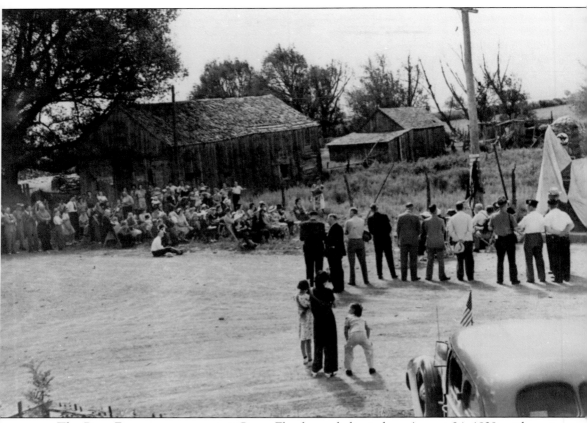

The Pony Express monument at Camp Floyd was dedicated on August 24, 1939, with a nice crowd attending. One of the round enamel horse-and-rider plaques designed by Perry Driggs can be seen just underneath the shroud. Was it later replaced with a Proctor plaque? The weathered wooden building at left was the old Walden Store. It is at the location of the current headquarters building and museum of Camp Floyd/Stagecoach Inn State Park in Fairfield, Utah. (Courtesy Utah State Historical Society.)

This War Department memorial, seen with bullet holes, was erected at the Camp Floyd Cemetery. It is thought that 83 soldiers and 1 civilian who died at Camp Floyd between 1858 and 1861 are buried in the cemetery. It must have been a bleak and forsaken place to end one's life. (Courtesy Utah State Historical Society.)

Coleman Wright Seal photographed the monument built to commemorate the Willow Springs Pony Express station in Callao, Utah, in 1939, while working for the CCC. The monument shows the round Proctor horse-and-rider plaque, as well as a rectangular plaque bearing a bit of local history. The station was located near the large trees in the background, on the Bagley Ranch, now Willow Springs Ranch. (Courtesy Utah State Historical Society.)

In this photograph, the CCC monument at Willow Springs in Callao, Utah, has been vandalized. The stonework was badly damaged when vandals removed the two bronze plaques. The monument has been restored and remains intact, with both the round Proctor plaque and the rectangular interpretive plaque replaced. Vandalism continues to be a serious problem for the monuments, signs, and markers in Utah's west desert. The National Pony Express Association works with the National Park Service and Bureau of Land Management to maintain signage and interpretive sites in western Utah. (Courtesy Utah State Historical Society.)

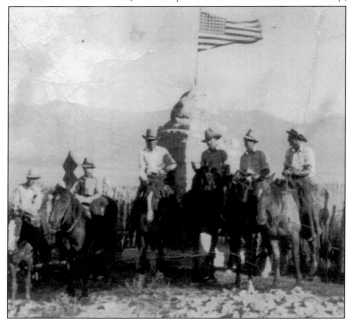

These riders stand in front of the stone Pony Express monument in Ibapah, Utah. The riders and horses are, from left to right, Kenneth Snivley, alias "Joe Bush," on Baldy; Wade Cook ("Cassidy") on Delphia; Blaine Hicks ("Blogo") riding Billy; Keith Chastain ("Hard Rock") with Cloudy; Dan Lee ("Boone") riding Socks; and William Kelly ("Wild Bill") on Deamo. (Courtesy Marilyn and "Pie" Linares.)

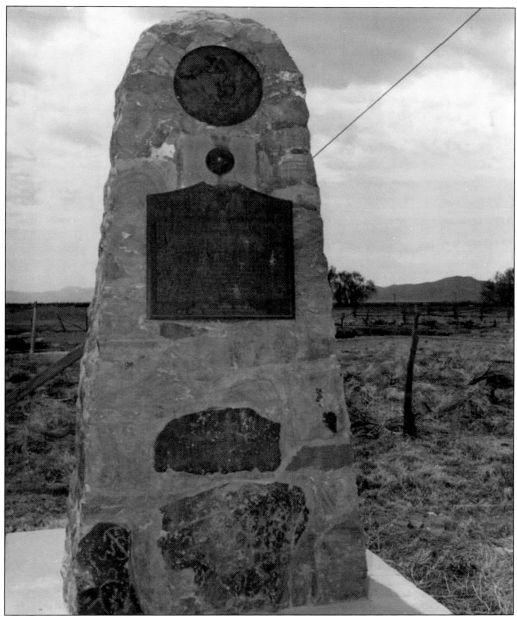

William P. Stephens photographed this monument at Camp Floyd in 1954. It bears the round Proctor rider plaque and an interpretive plaque provided by the Utah Pioneer Trails and Landmarks Association. Some of the larger rocks at the bottom of the monument bear Indian pictographs from the area. (Courtesy Utah State Historical Society.)

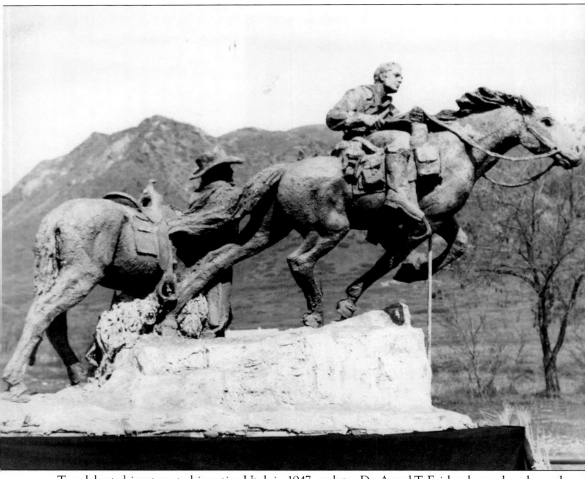

To celebrate his return to his native Utah in 1947, sculptor Dr. Avard T. Fairbanks produced a work honoring the Pony Express. His original 1947 product was done in papier-mâché and was featured in the Days of '47 Parade in Salt Lake City and in other local parades that year. The plan to have the statue cast in bronze was not carried out at that time, and the model disintegrated in the weather. The design was brought to life again almost 50 years later. (Courtesy Dr. David Fairbanks.)

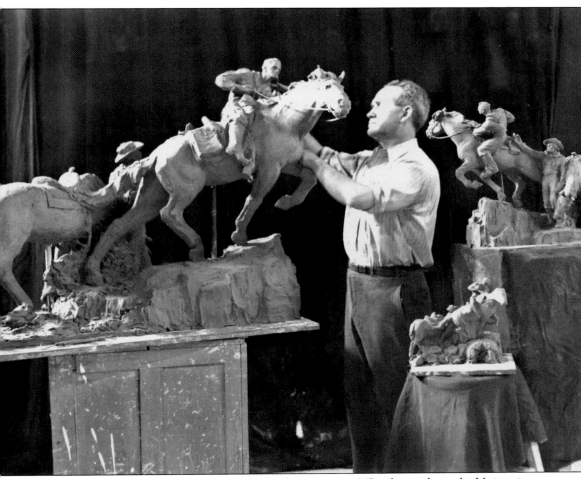

The world-renowned sculptor Dr. Avard T. Fairbanks is seen in 1947 in his studio at the University of Utah, working with clay models of his Pony Express statue. He worked on the statue in three sizes, progressing to its full size. With his mastery of anatomy, Fairbanks created sculptures that, if they could come to life, would have each bone, muscle, and sinew in the proper place and proportion for natural action and motion. (Courtesy Dr. David Fairbanks.)

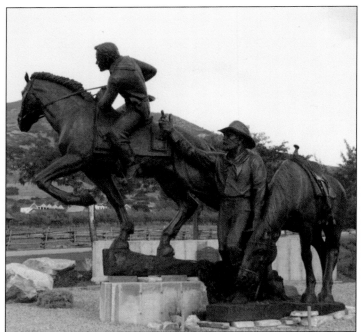

The Fairbanks Pony Express Memorial was erected at This Is the Place Heritage Park, just east of Salt Lake City, 51 years after the unveiling of the design. With final design touchup done by Skylight Studios in Boston, Massachusetts, and bronze casting by Adonis Bronze in Orem, Utah, the statue now stands 17 feet tall. It is a reminder of the young, intrepid riders, the stalwart and steady station keepers, and the fleet and surefooted horses that made the Pony Express work. (Photograph by Joseph L. Hatch.)

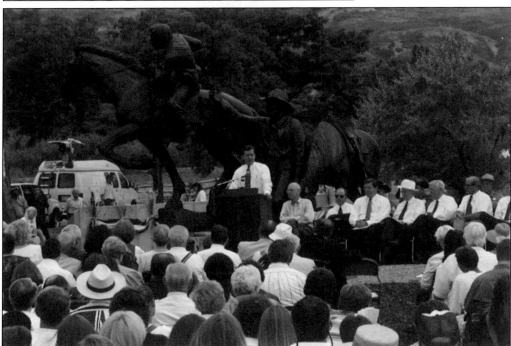

The Fairbanks statue was placed at This Is the Place Heritage Park and dedicated in July 1998. It was presented to the park by the Fairbanks family, the family of the late Alice Sheets Marriott, and the National Pony Express Association. Speakers at the ceremony included Utah governor Michael Leavitt (pictured) and Pony Express Association president Wayne Howard of Cozad, Nebraska. The statue was dedicated by LDS church president Gordon B. Hinkley. (Courtesy Patrick Hearty.)

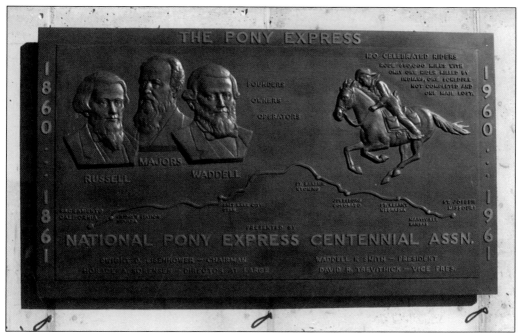

The Pony Express Centennial, celebrated in 1960, left an impressive legacy in memory of the historic mail service. This attractive bronze plaque honors the founders, Russell, Majors, and Waddell, and the speeding horse and rider. The trail's route across eight states is also represented. Plaques such as this one were placed at key locations all along the trail. (Courtesy Patrick Hearty.)

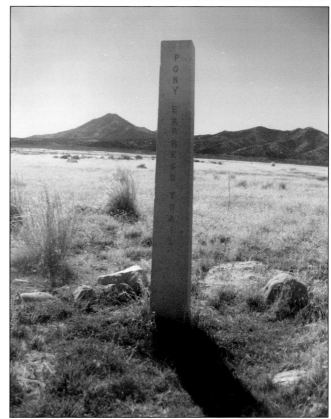

During the centennial celebration, the Bureau of Land Management erected cement posts along the trail in western Utah. The posts, about three feet tall, bear the words "Pony Express Trail." They were installed along the actual trail, which sometimes varies by a mile or more from the modern road. (Photograph by Joseph L. Hatch.)

Stone monuments such as the one shown here were built by the Civilian Conservation Corp in the 1930s and 1940s. At this site, commemorating Rush Valley Station, interpretive plaques telling the story of the Pony Express can be found. The plaques are provided by the National Park Service, and the site is maintained by the Bureau of Land Management and the National Pony Express Association. Similar interpretation can be found at Simpson Springs, Boyd's Station, and Round Station. (Photograph by Annette Hatch.)

The Pony Express Trail Association has designed and installed granite monuments such as the one shown here at Camp Floyd State Park. These monuments tell the story of the station found nearby and can be seen in many locations along the Pony Express National Historic Trail. Behind the granite marker is an interpretive kiosk placed by Utah State Parks. (Photograph by Joseph L. Hatch.)

Stained-glass windows, which possibly open like transoms, adorn the upper floor of the old Union Pacific Railroad Depot, formerly the Oregon Short Line Depot, in Salt Lake City. They feature various events and episodes in Utah frontier history; the one shown here honors the Pony Express. If the building is ever scheduled for demolition, the author would like to save this window. (Courtesy Utah State Historical Society.)

Eight

STATION SITES AS THEY APPEAR TODAY

Who has not wished they could travel back in time, to 1860, to meet the Pony Express riders in person and to see the operation of that historic enterprise? Unfortunately, we can only look back and wonder who they were and what their experience was like. So, people turn to books such as this one for a glimpse of the world as it appeared.

Expansion of cities and towns, farming, road and rail construction, and other types of development have irretrievably altered the landscape where the Pony Express stations once stood. Visitors on the trail stand beside the monuments and markers and listen for echoes of hoof beats. They stretch their imagination to try to envision the people and events of times past in places where all traces of the frontier have long since vanished. Long ago, a young, intrepid rider on a fleet mustang conquered mountain, river, and desert to deliver his cargo of precious mail.

Dr. Joseph L. Hatch has had a lifelong fascination with photography and the recorded image. He has long had a desire to preserve a visual record of history and its events. During numerous trips up and down the Pony Express National Historic Trail, he has photographed sites along the trail and the locations of the stations. This final chapter shows the result of his research and photographic efforts. He has often put forth extra effort and endured considerable inconvenience in trying to get the right shot. The result is both informative and visually pleasing. This chapter shows the locations of the Pony Express stations across Utah as they appear today.

Needle Rocks Station, or The Needles, stood on Yellow Creek just west of the Utah-Wyoming line. The station was named for an impressive rock formation just to the east of the station site, seen in the distance in this modern photograph. No description of the original station was recorded by contemporary travelers. In the area today are two stone foundations, in one of which has been poured a concrete slab. The station site is on private property. (Courtesy Dr. Joseph L. Hatch.)

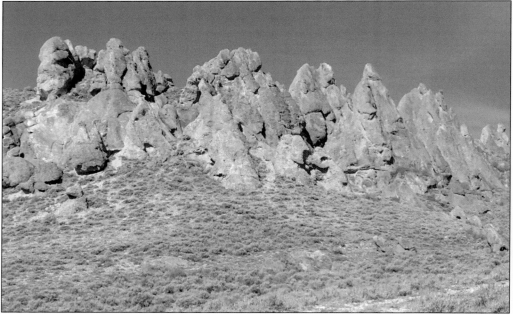

The Needles is a conglomerate stone formation that overlooked the pioneer road as it approaches Yellow Creek. This prominent landmark was noted in most pioneer journals and accounts of the trail, and it still catches the attention of the occasional traveler. (Photograph by Annette Hatch.)

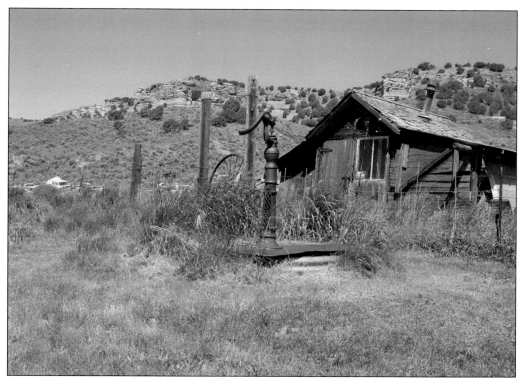

Castle Rock, or Head of Echo, was located at the foot of the rock formation called Castle Rock, shown here. The rock formations line up well with those seen in an 1868 photograph by A.J. Russell (see page 53). The original stage and Pony Express station was built of logs. The old building seen here does not date from Pony Express times, but the pump in the foreground locates the site of the spring that served the station. It still provides water for the Moore family residence. This station site is on private property. Please respect the rights of the owners. (Courtesy Dr. Joseph L. Hatch.)

The site of Halfway, or Hanging Rock Station can be found near the railroad stop called Emory. The spring that provided water is still flowing on the flat where the station stood. Rock outcroppings seen here near the top of the hill correspond with those seen in the historic photograph of the station on page 53. The site is on private property. (Courtesy Dr. Joseph L. Hatch.)

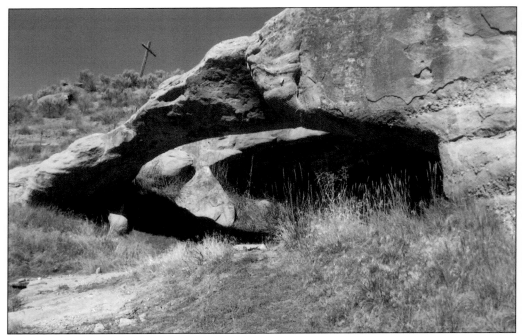

This natural stone arch or bridge is the "hanging rock" for which the station halfway down Echo Canyon was sometimes called. It can be seen on the old road just to the south and west, around a rocky point from the station site. (Courtesy Dr. Joseph L. Hatch.)

Steamboat Rock still towers over Echo Canyon, much as it did in pioneer times. Some of the red sandstone cliffs in the canyon are popular with rock climbers. (Courtesy Dr. Joseph L. Hatch.)

The Weber Stage and Pony Express Station is believed to have been located near the lower right of this photograph, probably inside the freeway interchange. Construction of the railroad, US Highway 30, Interstate 80, and other developments have so altered the topography that the exact location cannot be determined. Some sources describe a station house at Weber, built in 1853, with stone walls 26 inches thick. (Courtesy Dr. Joseph L. Hatch.)

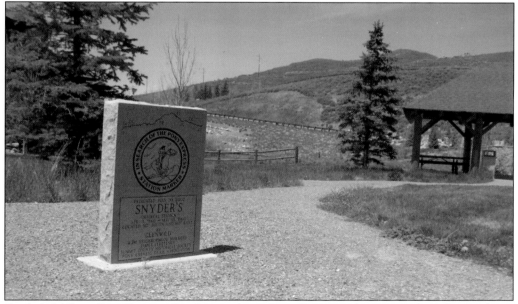

Snyder's Mill on East Canyon Creek served as a Pony Express relay station for a few weeks in early 1860. This granite monument was erected by the Pony Express Trail Association at a small public park called Glenwild. It stands a short distance north of the mill site. (Courtesy Dr. Joseph L. Hatch.)

The probable location of Dixie Hollow, or East Canyon Station was at the far right of this photograph. A rock pile and rock alignment suggesting the station foundation can be found there. Archeological investigation has yielded considerable evidence of occupation in the area, including numerous horseshoes and mule shoes, and even blacksmithing tools at the site just to the south, where the stable and corral were apparently located. The site is on private property. (Courtesy Dr. Joseph L. Hatch.)

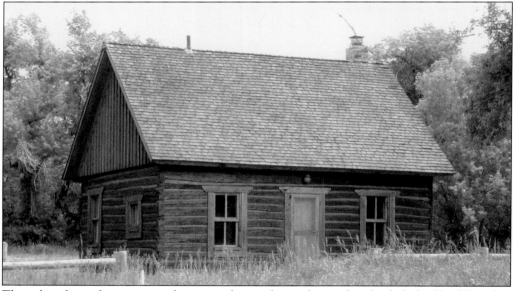

The cabin shown here is, according to tradition, the modernized and refurbished building that served as Bauchmann's, or Carson House Station. It has been moved approximately 100 yards south and west from the original station site. It is constructed of squared logs and stands nearer to East Canyon Creek than the apparent original location. The station is on private property. (Courtesy Dr. Joseph L. Hatch.)

Distances recorded by contemporary writers fail to establish the exact location of Mountain Dell, or Hanks' Station. Archeological research in the area has only partially resolved the question. The station on Big Canyon Creek probably consisted of a log cabin and a large barn, referred to as the Wells Fargo Barn. Willow Spring, which likely provided water for the station, still flows, but all traces of buildings or other structures in the area have been obliterated. (Courtesy Dr. Joseph L. Hatch.)

Salt Lake House served as a Pony Express home station where the riders lived between mail runs (see page 43). The address was 143 South Main Street. This location is currently occupied by the Tribune Building, long the home of the *Salt Lake Tribune*. The building now houses Neumont University. Here, Dr. Joseph Hatch stands in front of the Tribune Building about 2010. Near him is an attractive bronze plaque, placed by the Daughters of the American Revolution in 1924, honoring the Pony Express. (Courtesy Patrick Hearty.)

Porter Rockwell's Hot Springs Brewery & Hotel was located toward the center of this photograph. All evidence of the station or its component buildings has long since been destroyed, but the authors found adobe bricks from the old barn in this area prior to the most recent round of construction activity. The site is on private property. (Courtesy Dr. Joseph L. Hatch.)

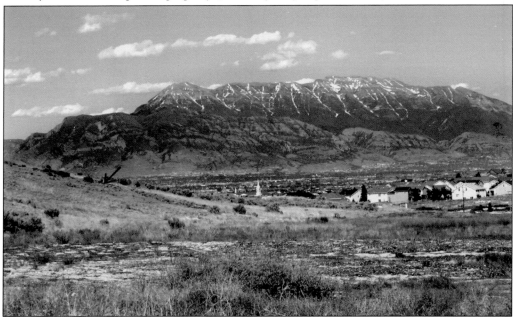

Joe's Dugout, or simply Dugout, stood on a side hill adjacent to the Pony Express Parkway in present-day Eagle Mountain, Utah. No evidence remains of the stone house or large barn built here in pioneer times. The spectacular view of Mount Timpanogos remains and can still be enjoyed. (Courtesy Dr. Joseph L. Hatch.)

The Pony Express Station at Camp Floyd stood near the center of this photograph. It was a small structure of adobe construction, located about one block east of John Carson's Inn, now Stagecoach Inn. At left is the Fairfield District School, built in 1898. The one-room building, which is listed in the National Register of Historic Places, now serves as a community center and venue for schoolchildren on field trips to study Utah history. (Courtesy Dr. Joseph L. Hatch.)

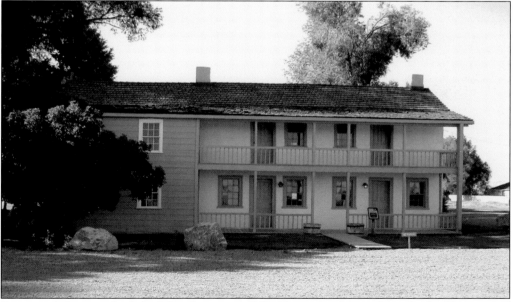

Stagecoach Inn was built by John Carson in 1858. Known as Carson Inn, the building served as home for his family and for the accommodation of travelers. Well-known travelers of the day, including Horace Greeley, Sam Clemens, and Sir Richard Burton, passed this way. Today, the inn is open as a museum, giving visitors a glimpse into life in the 1860s. A beautiful park adds to the charm of the location. The building is listed in the National Register of Historic Places. (Courtesy Dr. Joseph L. Hatch.)

About 10 miles west of Camp Floyd stands the CCC monument marking the location of East Rush Valley, Pass, or No-Name Station. No description of the station has been found, and no physical evidence can be seen on the ground. (Courtesy Dr. Joseph L. Hatch.)

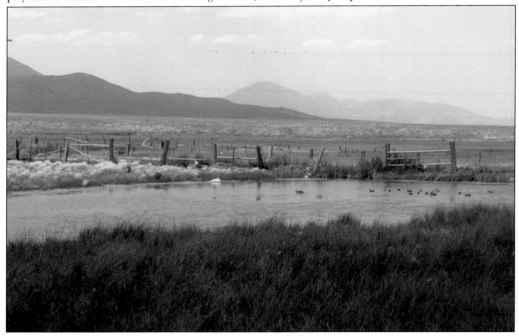

Rush Valley Station, the first home station west of Salt Lake City, was also known as Meadow Creek. No evidence of the station remains at the site. The stone CCC monument that commemorates the station and where interpretive information can be found has been moved to a location along State Highway 36, probably a mile north of where the station stood. The site is on private property. (Courtesy Dr. Joseph L. Hatch.)

A rock alignment and this stone monument erected by the CCC mark the location of Lookout Pass, or Point Lookout Station. Later in the 1860s, after the days of the Pony Express, the cabin here was occupied by Horace Rockwell, brother of Porter, and his wife, Libby. Across Brush Hollow from the station site stands the stone enclosure of a small cemetery built for Libby Rockwell's beloved pet dogs (see page 63). (Courtesy Dr. Joseph L. Hatch.)

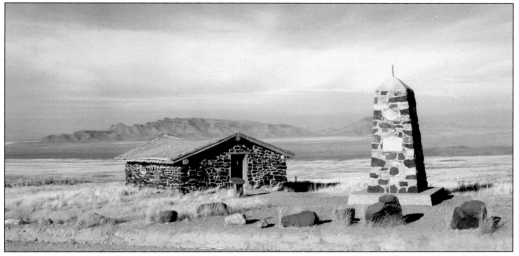

At the site of Simpson Springs Station is a stone station reconstruction built in 1975 by the Tooele High School Future Farmers of America. The CCC monument at Simpson is the largest found at any Pony Express site in Utah. It still bears the original bronze plaques (the plaques have been stolen from many other monuments). Also in the area are the stone ruins of a house built by Alvin Anderson in the late 1800s. The Bureau of Land Management has built an interpretive site near the station and a campground in the foothills of the Simpson Mountains just southeast of the monument and station site. (Courtesy Dr. Joseph L. Hatch.)

Riverbed Station sat in the dry riverbed of the old Sevier River. It may have been constructed too late to serve the Pony Express, but a CCC monument marks the location nonetheless. A rock foundation alignment and a depression, possibly indicating an attempt at a well, can still be seen near the monument. (Courtesy Dr. Joseph L. Hatch.)

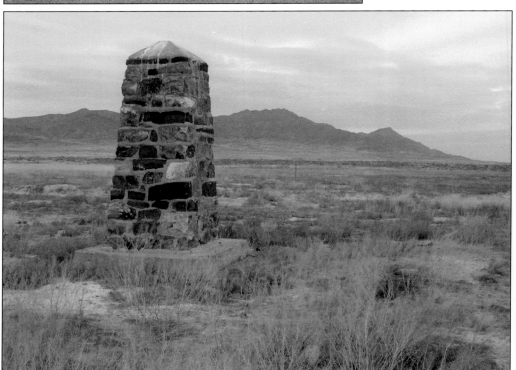

Horace Greeley described Dugway, or Shortcut Pass Station as "about the forlornest spot I ever saw." The station was described as a dugout roofed with split cedar logs, with a rude adobe chimney. In all, three wells were attempted, the deepest going down more than 150 feet. Water still had to be hauled in. The site is about a mile south of the Pony Express Road, just east of Dugway Pass. (Courtesy Dr. Joseph L. Hatch.)

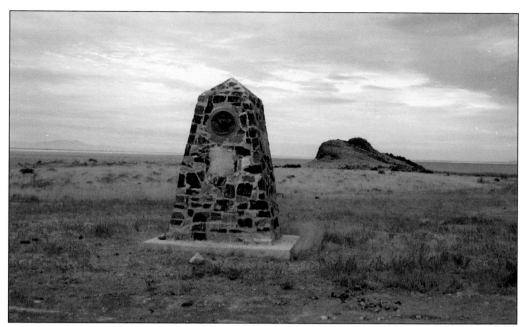

An outcropping of black volcanic rock and a CCC monument announce a traveler's arrival at Blackrock Station. It may also have been known as Blackrock Springs, though no springs are evident in the area today. The station was constructed of the black rocks abundant at the location. Little is known about the station or its usage. (Courtesy Dr. Joseph L. Hatch.)

Fish Springs was, at least for a part of the Pony Express era, the second home station for riders west of Salt Lake City. The station site is now a part of the 18,000-acre Fish Springs National Wildlife Refuge, an important stop on the migration routes of dozens of species of migratory birds. The CCC monument stands adjacent to the Pony Express Road, some distance west of the station site. (Courtesy Dr. Joseph L. Hatch.)

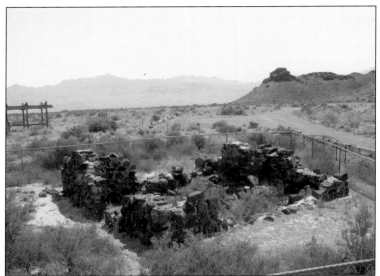

Boyd's Station, also called Butte, or Desert Station, is located just west of the Fish Springs Mountains. The ruins of the one-room stone cabin have been stabilized, and an interpretive site is maintained under a cooperative agreement between the National Park Service, Bureau of Land Management, and National Pony Express Association. (Courtesy Dr. Joseph L. Hatch.)

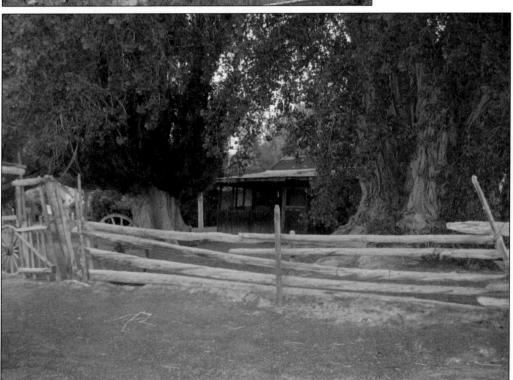

The old station house still stands as a ranch outbuilding on Andersons' Willow Springs Ranch in Callao, Utah. Family tradition asserts that Willow Springs was a Pony Express home station (members of the Bagley family have been on the ranch since the 1890s). Originally consisting of three rooms (only two remain), the adobe building has been covered with wood to protect the old adobes from further deterioration. The immense old willow trees around the station building were brought by wagons to the ranch as saplings around 1860. The site is on private land. (Courtesy Dr. Joseph L. Hatch.)

The tall trees and green fields of Callao, Utah, gladden the heart of the traveler after many miles of dusty desert. Willow Springs Station must have had the same effect on Pony Express riders and stagecoach passengers in the 1860s. CCC workers stationed at the camp near Callao built this monument commemorating Willow Springs Station. (Courtesy Dr. Joseph L. Hatch.)

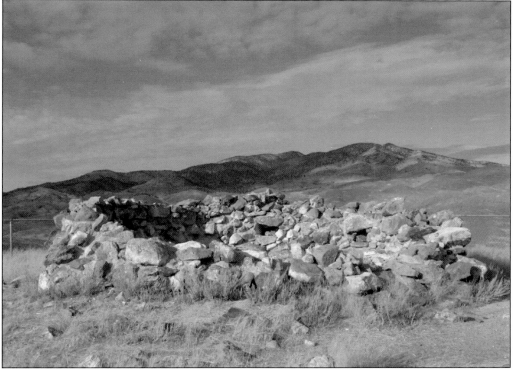

The round fortification called Round Station was built in 1863 as part of the third iteration of Canyon Station for the service of the stagecoach line. Prior to this, two previous Canyon Stations had been raided and destroyed, hence the hilltop location and round fort to defend against marauding Indians. A rock foundation where the station house stood can be seen just to the east of the fort. An interpretive site constructed by the Bureau of Land Management and maintained by the National Park Service, BLM, and National Pony Express Association is located nearby. (Courtesy Dr. Joseph L. Hatch.)

The first Canyon Station, built where Blood Canyon empties into Overland Canyon, was of short duration. The second Canyon Station (also known as Burnt Station) was located on Clifton Flat, at the head of Overland Canyon, about 100 yards up the hill from this CCC monument. In July 1863, the station was attacked and burned by Indians in retaliation for an attack on an Indian village by Col. Patrick Connor's troops from Fort Douglas. At least five stage-line employees and soldiers were killed when the station was destroyed. (Courtesy Dr. Joseph L. Hatch.)

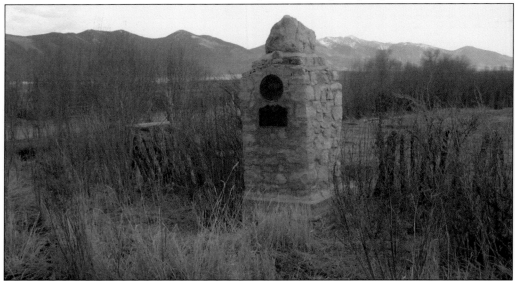

The valley was called Deep Creek, because the creek was in a deep ravine, not because its waters were deep. According to local history, a small swing station for the exchange of Pony Express horses was located at the Church Ranch, a little south and west of the present village of Ibapah and not far from this stone marker. This station would have been located about three miles south of the Egan Ranch. The monument shown is not one of those erected by CCC workers. It is topped by a peculiar beehive-shaped cement dome. (Courtesy Dr. Joseph L. Hatch.)

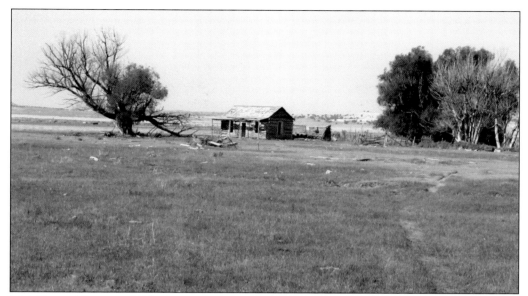

Maj. Howard Egan established a ranch and mail station in Deep Creek Valley in 1859. He worked for George Chorpenning's pioneer Jackass Mail service before the days of the Pony Express. Egan was hired by Russell, Majors & Waddell as superintendent over the portion of the Express line between Salt Lake City and Roberts Creek in present-day Nevada. The cabin shown here is believed to date from the 1860s and Egan's time. The site is on private property. (Courtesy Dr. Joseph L. Hatch.)

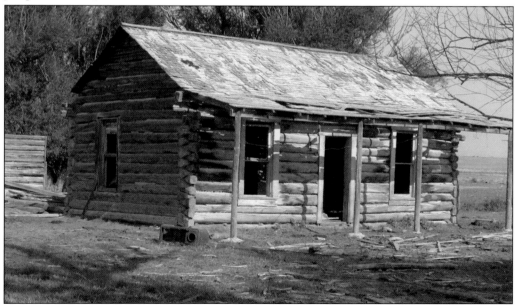

Howard Egan's ranch in Deep Creek Valley served the overland stage line. If not a Pony Express station, hay and provisions grown on the ranch were used to supply the more remote stations to the west. Egan's son, Howard R. Egan, lived on the ranch for many years after the end of the Pony Express era. He recorded many fascinating tales of the lives of both Indians and white settlers in that remote desert valley 150 years ago. (Courtesy Dr. Joseph L. Hatch.)

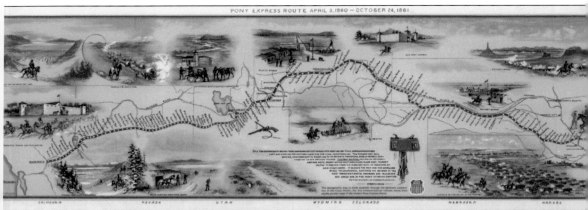

As seen on this map by William Henry Jackson, the Pony Express Trail entered present-day Utah at the Wyoming border a few miles south of Evanston, Wyoming. The trail ran southwest through Salt Lake City, entering present-day Nevada at Ibapah, about 60 miles south of Wendover. The stations, listed from east to west, are Needle Rocks, or The Needles; Head of Echo, or Castle Rock; Halfway, or Hanging Rock; Weber, Echo, or Bromley's Station (home station); Dixie Hollow, or East Canyon; Carson House, or Bauchmann's; Mountain Dell, or Hanks' Station; Snyder's Mill; Salt Lake House (home station); Travelers' Rest, or Traders' Rest; Rockwell's; Joe's Dugout; Carson Inn, or Camp Floyd; East Rush Valley, Pass, or No-Name; Rush Valley, or Meadow Creek (home station); Lookout Pass, or Point Lookout; Simpson Springs; Riverbed; Dugway, or Shortcut Pass; Blackrock; Fish Springs (home station); Boyd's, Butte, or Desert Station; Willow Springs (home station); Canyon, or Burnt Station; and Deep Creek Station. (Wikipedia.)

BIBLIOGRAPHY

Burton, Richard F. *The Look of the West, 1860*, reprint of 1862 original. Lincoln, NE: University of Nebraska Press, 1963.

Carter, Kate B. *Utah and the Pony Express.* Salt Lake City, UT: Utah Printing Co., 1960.

Greeley, Horace. *An Overland Journey from New York to San Francisco in the Summer of 1859.* New York: Saxton, Barker & Co., 1860.

Hearty, Patrick, and Dr. Joseph L. Hatch. *The Pony Express Stations in Utah.* Salt Lake City, UT: 2012.

Jabusch, David, and Susan Jabusch. *Pathway to Glory: The Pony Express and Stage Stations in Utah.* Salt Lake City, UT: Treasure Press, 1996.

Lewin, Jacqueline, and Marilyn Taylor. *On the Winds of Destiny: A Biographical Look at Pony Express Riders.* St. Joseph, MO: Platte Purchase Publishers, 2002.

Majors, Alexander. *Seventy Years on the Frontier.* Minneapolis, MN: Ross and Haines Inc., 1965.

DISCOVER THOUSANDS OF LOCAL HISTORY BOOKS FEATURING MILLIONS OF VINTAGE IMAGES

Arcadia Publishing, the leading local history publisher in the United States, is committed to making history accessible and meaningful through publishing books that celebrate and preserve the heritage of America's people and places.

Find more books like this at
www.arcadiapublishing.com

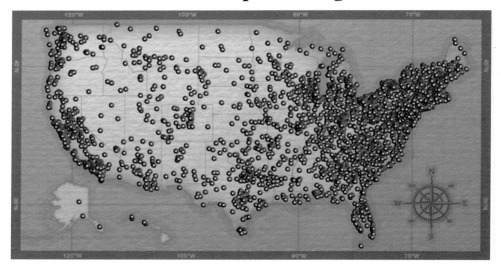

Search for your hometown history, your old stomping grounds, and even your favorite sports team.